IMAGES
*of America*

# WOODSIDE

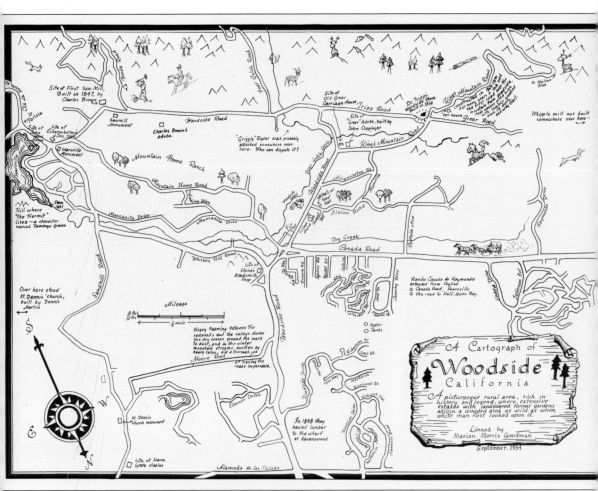

Within the map:

A Cartograph of
**Woodside**
California

*A picturesque rural area, rich in history and legend, where extensive estates with landscaped formal gardens adjoin a wooded area as wild as when white man first looked upon it.*

Limned by
Marian Morris Goodman

September, 1954

**CARTOGRAPH, 1954.** Limned by Marian Morris Goodman, this cartograph was originally published in the "Woodside News," a newsletter compiled and edited by Doris Davis. The cartograph shows major roads and various historic sites along with charming illustrations. The caption on this more or less accurate map reads, "A picturesque rural area, rich in history and legend, where extensive estates with landscaped formal gardens adjoin a wooded area as wild as when white man first looked upon it."

**ON THE COVER:** Dr. Robert Orville Tripp built one of the first settlements in this area. This 1898 photograph shows his historic Woodside Store, which has been restored and is a registered California landmark. The dry goods store also served as a post office and library. Tripp was also involved in lumbering, dentistry, and winemaking.

IMAGES
*of America*

# WOODSIDE

Thalia Lubin and Bob Dougherty
with the Woodside History Committee

ARCADIA
PUBLISHING

Published by Arcadia Publishing
Charleston, South Carolina

Printed in the United States of America

Library of Congress Control Number: 2009943766

For all general information, please contact Arcadia Publishing:
Telephone 843-853-2070
Fax 843-853-0044
E-mail sales@arcadiapublishing.com
For customer service and orders:
Toll-Free 1-888-313-2665

Visit us on the Internet at www.arcadiapublishing.com

*This book is dedicated to historian Jacques Audiffred, whose photographs were a major contribution to this project, and to former Woodside mayor Jeanne Dickey, who inspired the Woodside History Committee in its preservation efforts.*

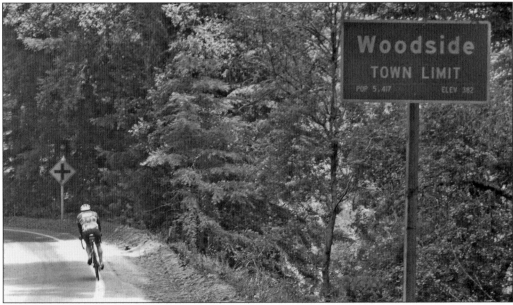

TOWN LIMIT SIGNS. Don't call it a city! Longtime resident L. Jay Tenenbaum spearheaded the effort to convince the State of California to issue new official signs for Woodside, showing it as a town, not a city. Since its incorporation in 1956, the population has remained fairly stable between 4,000 and 6,000 residents. Early settler Dr. Tripp first named the area Woodside in the 1850s.

# CONTENTS

# ACKNOWLEDGMENTS

Thalia and Bob wish to thank the following people and groups for their photographs, research, assistance, and support in the preparation of this book: current and past Members of the Woodside History Committee, including Richard Tagg, Patty Hallett Nance, Bob Mullen, Dolores Degnan, Gretchen Tenenbaum, Delia Ehrlich, Lisha Mainz, Jennifer Werbe, Cutty Smith, Bill New, Sonja Davidow, and Barbara Wood; archivist Jeanne Thivierge; historian Jacques Audiffred and family; John Volpiano; Harold and Irenne Zwierlein; Sam Whiting; Beverley Toombs; Trish Hooper; Jan Harper; George and Kathie Roberts; Jim Caldwell; the Veliquette/Rice family; Ken Fisher; Patsy Kahl; Marsha Bondurant; town manager Susan George; assistant town manager Kevin Bryant; the Woodside Town Hall staff; Woodside Town Council members Anne Kasten, Peter Mason, Sue Boynton, Ron Romines, Deborah Gordon, Dave Burow, Dave Tanner; Sandy Fontana; Lynn Shortsleeve; town clerk Janet Koelsch; planning director Jackie Young; Marilyn Dyer; Stan Larsen; Mike Fuge, Karen Peterson; Janet Self; Nancy Lund; Bob Moll; Bud Foss; Kathy Felix; Larene Hallett; Jim Bibbler and family; Susie Bors; Ursula Eisenhut; Peter Rich; Stephen Lubin; Mike Piper; Howard Hickingbotham; Andy Alcon, of Crosspoint Ventures Partners; Dick Morton; Gaylynne Mann; Sharon Schweninger Humphreys; San Mateo County Historical Association; Kathy Fay and family; Maggie Mah; Fentress Hall; Sally Lemoin Rathbun; Fran Roesler; Jeannette Rettig; Gladys Martinez; Rick Leitritz; Ida Roggen; Peter Uchman; Joe Geist; Gilbert and Sally Richards; Bob Stiff; Don and Sandy Pugh; Dennis Duncan; Rick DeBenedetti; the Shack Riders; Loel McPhee; Clotilde Luce and Uphold Our Heritage; John Poultney; Adolph Rosekrans; Elizabeth Stevenson; Fritz Kasten; Judy Sieber; Leslie Johnson; Carolyn Douglas; Charlie Catania; the Redwood City Library; and the La Honda Historical Society.

We have made every effort to gather historical photographs, interesting stories, and accurate information while compiling this book. Any errors or omissions are inadvertent. Unless otherwise noted, all images appear courtesy of Woodside History Archives.

For more information, please contact woodsidehistory@woodsidetown.org or visit the Woodside Community Museum.

# INTRODUCTION

Woodside is located on the eastern edge of the Santa Cruz Mountains, between Silicon Valley and San Francisco. Its temperate weather and natural beauty are two of the elements that attracted the indigenous people and continue to attract residents to this area.

The story of Woodside begins with the Ohlone people, who made their home in the area for thousands of years before Spanish explorers arrived. These native people enjoyed plentiful good water and an abundant food supply. The Lamchin band of Ohlone made their living by hunting, fishing, and gathering food in the grassy meadows and forested hillsides. The life of the Ohlone changed dramatically after the arrival of the Europeans. Many lost their land, died from diseases brought by the Spaniards, or were forced into servitude at the nearby Spanish Missions.

Mexico, along with its territorial holdings in California, won independence from Spain in 1821. In the 1830s, the Woodside area became home to many English-speaking settlers on the San Francisco Peninsula. Their appearance marked the beginning of the lumbering economy, which assisted San Francisco with its increasing timber needs. Some of those seeking their fortunes in the redwoods were deserters and drifters, but others emerged as community builders and leaders.

Following the secularization decree of 1833, Mexican authorities granted to loyalists 18 ranchos in present day San Mateo County. One of the largest, Rancho Cañada de Raymundo, was in the middle of the San Francisco Peninsula, encompassing most of present day Woodside. The rancho boundaries were from Alambique Creek, on the south, to lower Crystal Springs Lake, on the north, and from Skyline to Cañada Valley. The United States acquired California in 1848, after the Mexican-American War.

By 1852, regular stagecoach service ran to and from San Francisco, and many settlers were attracted to this area. Dr. Robert Tripp and Mathias Parkhurst, credited with naming the settlement Woodside, opened the first general store, post office, and circulating library at the present-day intersection of Kings Mountain and Tripp Roads. The Woodside Store was the center of the new community until the 1880s, when other commercial businesses opened nearby.

The first school in the new settlement was called Greersburg Elementary School (changed to Woodside Elementary School in the 1950s). What is now Woodside consisted of small clusters of businesses and residences that developed at important intersections. The Whiskey Hill and Woodside Road intersection grew in importance because it was located between the sawmills and the port in Redwood City, where logs were brought to the docks for transportation to various San Francisco Bay locations.

By the 1880s, the luxuriant stands of redwoods in this valley had been logged. However, the good soil and climate remained and people began to seek other uses, such as vineyards and other agriculture, for the fertile land. As the early pioneer families passed on and their landholdings were subdivided, large tracts of land became available.

Many successful San Francisco and San Francisco Peninsula families built their country estates in the Woodside area during the early part of the 20th century. Beginning in the 1920s, Woodside

experienced an increase in residential and commercial development. The steady encroachment of suburban development alarmed local residents, whose concern for the effects that growth might have on Woodside caused them to consider incorporating as a town. The idea was first proposed in 1928 at a meeting of residents at the Jackling estate.

The Woodside Civic League was formed in 1952 to address this threat of encroaching development. The Civic League determined that by incorporating as a legal entity, they could better look after their own interests instead of relying on the county. In 1954, a group of women led by Jean Russell opened an office called The Bulletin Board in the town center as a place to provide information about the proposed incorporation. They suggested boundaries for the town limits to include about 11 square miles, with about 3,000 residents, and they circulated a petition for an incorporation election. On October 21, 1956, Woodside approved incorporation by a close vote and elected its first town council.

Woodside cherishes its annual traditions, like the May Day Parade, begun in 1922, which requires an official closure of State Highway 84. Held annually on the first Saturday of May, the grand procession includes schoolchildren in costumes on homemade floats, town officials, the fire department, the Los Trancos Woods marching band, horse riders, and others.

Newer traditions followed, like the July 4th Junior Rodeo and Day of the Horse, which celebrate the role of horses in Woodside. These events allow townspeople to appreciate the rich history of Woodside's enduring good fortune in both resources and residents. In 2006, Woodside celebrated the 50th anniversary of its incorporation. Recent years have seen tremendous growth in surrounding communities because of the success of technology, research, investment, and other industries in the area. Yet, thanks to the diligence of its citizens and officials throughout the years, Woodside retains its rustic charm, with tree-lined country lanes, magnificent vistas, historic buildings, and sites dating back to the early days of European settlement in San Mateo County.

Woodside continues to maintain its rural character and remains a very desirable place to live.

# One

# THE INVASION OF EDEN

For over 3,000 years before the arrival of the Spanish explorers, Woodside was home to a peaceful, loose-knit group of communities who lived in relative stability in the surrounding hills and valleys. The temperate climate and bountiful land provided a continuous food supply consisting of deer, salmon, steelhead, crustaceans, berries, and acorns. The Spanish called the indigenous people in California the Costanoans, meaning coast people, and the people near Woodside were part of a subtribe called the Ohlone. Until this point, the primary fear of the Ohlone was the grizzly bear, but that would soon change.

Spanish captain Gaspar de Portolá set out from Mexico in 1769 in search of the great bay of Monterey, which had been reported by sailors exploring the California coast. Portolá's small group of explorers camped near what is now Woodside, marking the first documented appearance of Europeans in this area. Subsequent settlement by these new arrivals resulted in the relocation of the Ohlone to the Spanish Missions, where they worked in slave-like conditions in the orchards and vineyards and helped to raise cattle. Diseases brought by the Spanish, land grabs, and other hostilities caused the demise of the Ohlone, and their numbers were greatly diminished by the 1830s.

In 1821, after 300 years of colonial rule, Mexico won its independence from Spain. The land holdings, which included most of what is now California, were secularized in 1833 by the Mexican government, transferring the mission lands from the padres to loyal veterans of the Mexican War. The land grants were known as ranchos, and the grantees were called Californios. Rancho Cañada de Raymundo, encompassing most of present day Woodside, was awarded to John Copinger for assisting Mexican government official Juan Bautista Alvarado in a dispute with Mexican authorities.

By 1846, Pio Pico, the governor of Mexican Alta California, publicly expressed his concern about the great influx of "Yankees" to the area, but by then it was too late. Mexico lost the California territory in the two-year Mexican-American War, and in 1850, California became the 31st state in the Union.

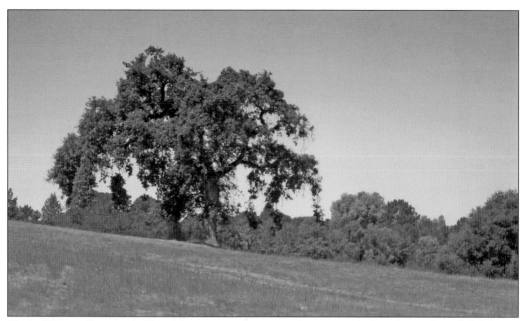

**OAKS (GENUS *QUERCUS*).** Several varieties of native oak trees, including live oak and deciduous blue oak, provided sustenance to the native people and continue to be the dominant trees in the local landscape. The Woodside Conservation and Environmental Health Committee hosts a program to honor Woodside citizens who have preserved a heritage tree on their property. The Heritage Tree Award is presented at the Woodside Environment Fest.

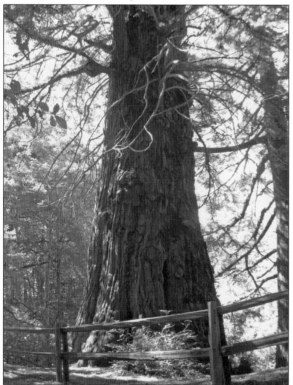

**COAST REDWOOD (*SEQUOIA SEMPERVIRENS*).** Redwoods are at the very core of Woodside's history. The wood from these magnificent tall trees has been used for building from the time of the Spanish Missions. Redwoods are resistant to rot and insects, and their lack of resin makes them resistant to fire. This tree, named Methuselah and estimated to be 1,800 years old, is the oldest standing redwood on the San Francisco Peninsula. It has a 14-foot diameter and was 225 feet tall before its top broke in 1954.

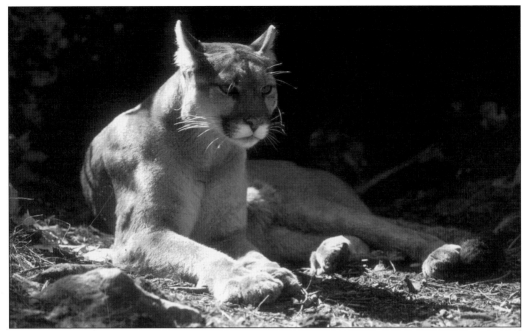

**MOUNTAIN LION (*FELIS CONCOLOR*).** This solitary animal exists mainly in the western United States and Canada and feeds on deer, rabbits, skunks, and other small animals. The elegant cat and its habitat pathways are protected under the California Wildlife Protection Act of 1990, which prohibits sport hunting of mountain lions. An important part of the biodiversity of this area, these animals generally avoid people, but sightings continue to increase as development encroaches on their habitat. (Courtesy US Forest Service.)

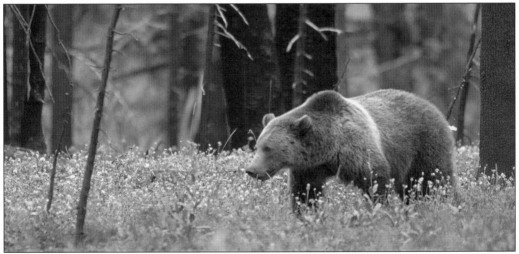

**GRIZZLY BEAR (*URSUS ARCTOS HORRIBILIS*).** The emblematic grizzly bear on the California flag is extinct in the state, making it difficult to imagine the terror that they caused. In the 1800s, while looking for lost oxen, a man named Ryder accidentally encountered a mother grizzly with cubs. The bear grabbed Ryder, who stabbed it with his knife until it let go. Ryder fell down a ravine and was again attacked by the bear; its final blow tore off Ryder's ear and part of his face. He awoke in the Brown Adobe to an old man stitching his wounds with a canvas needle and string. Bear Gulch Road was named after this incident. (Courtesy US Forest Service.)

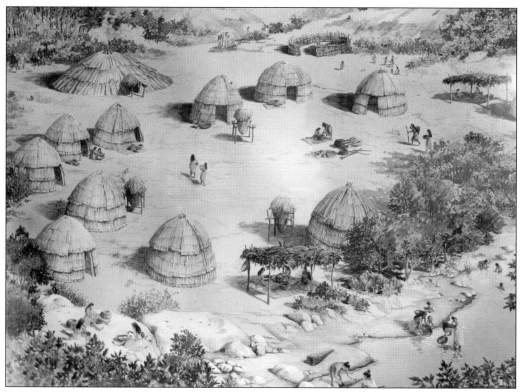

**OHLONE VILLAGE.** The Ohlone were the indigenous people of the area who greeted the first Spanish explorers in 1769. The bountiful resources and temperate climate allowed them to live in relative comfort without the need to raise crops or herd animals. Regardless of tribe affiliation, the Spanish called all indigenous people in the San Francisco Bay area "Costanoan," meaning coast people. (Courtesy Zwierlein family; painting by Dan Quan.)

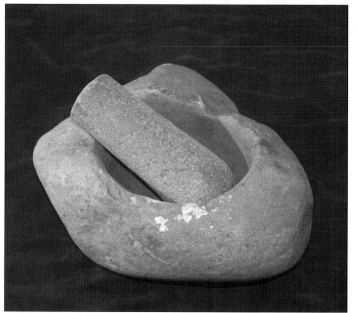

**OHLONE MORTAR AND PESTLE.** The Ohlone used stone tools to grind oak acorns into meal, and then they leached out the bitter tannins to make nourishing stews and other foods, providing most of the carbohydrates in their diet. From before the time of the Egyptian pyramids, these indigenous people were experts in using the local flora and fauna to sustain themselves. They hunted deer, fished in the San Francisco Bay, and gathered berries and nuts to store for the winters. (Courtesy Zwierlein family.)

**OHLONE DIG AT FILOLI, 1977.** Ohlone burial grounds were discovered at the Filoli estate and researched by Cañada College students. The surviving Ohlone persist in their struggle for tribal status recognition by the US government. Meanwhile, contemporary archeologists continue to gain a deeper understanding about this ancient culture through their artifacts. (Courtesy Zwierlein family.)

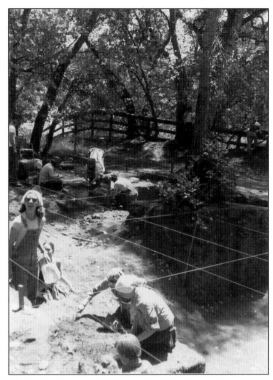

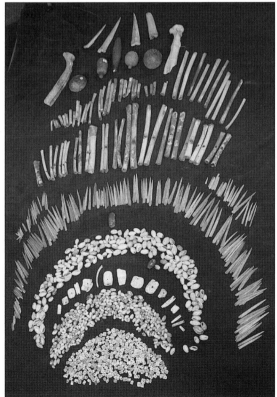

**ARTIFACTS AT FILOLI DIG, 1977.** Stone and animal bone tools, shells, and beads are among several thousand artifacts discovered at Filoli, including 85 human burials, which were privately reinterred. The Ohlone created watertight cooking vessels by weaving local grasses and reeds into utilitarian and ceremonial baskets. Although very few of these intricately designed baskets survived, other burials and artifacts continue to be discovered near watercourses and creeks. (Courtesy Zwierlein family.)

**GASPAR DE PORTOLÁ.** Spanish *comandante* Gaspar de Portolá arrived in the area in 1769, searching for sites to establish Franciscan missions. Wanting to protect their Mexican colony from possible Russian and British threats, the Spanish established a military and religious presence. Portolá's expedition passed by present-day Cañada College accompanied by diarist Father Juan Crespi, who noted many small villages. The Portolá party was greeted warmly by the natives, who mistakenly assumed that the members were newly arrived trading partners.

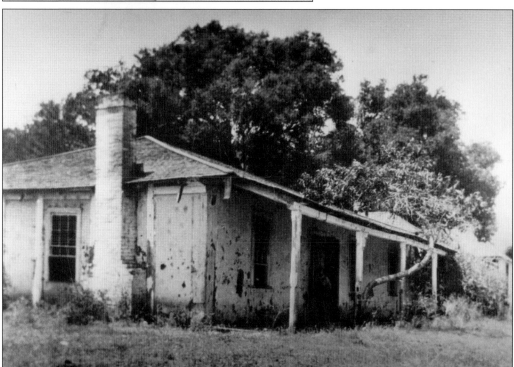

**COPINGER-GREER ADOBE.** This clay brick house was built in 1840 on the original Rancho Cañada de Raymundo land grant, which consisted of 12,545 acres. Mexican governor Juan Bautista Alvarado awarded the grant to John Copinger as a reward for his help in a revolt against Mexican authorities in Monterey in 1836. Copinger died in 1847 at the age of 37 and is buried at Union Cemetery in Redwood City.

**SAN ANDREAS GEOLOGIC FAULT.** This geologic fault extends over 800 miles (including the length of the San Francisco Peninsula), creating a rift valley that holds Crystal Springs Lakes and passes through Woodside. Long before the famous 1906 earthquake, early settlers recorded many temblors. In 1989, another strong earthquake on the fault shook the entire region, killing scores of people and damaging freeways and buildings. (Courtesy US Geological Survey.)

**FIRST NEUMAN BROS. STORE AFTER 1906 EARTHQUAKE.** As the saying goes, "earthquakes don't kill people, buildings do." Fortunately, most structures in Woodside were built of wood, which is flexible and able to resist complete collapse, giving occupants a better chance of escape. Both the Neuman Bros. Store and the pump house were destroyed in this earthquake, but no deaths were reported in the town.

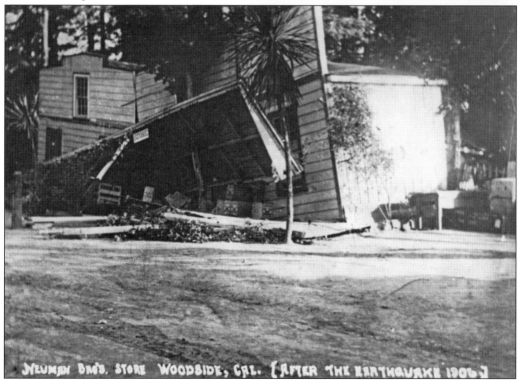

NEUMAN BROS. STORE WOODSIDE, CAL. [AFTER THE EARTHQUAKE 1906]

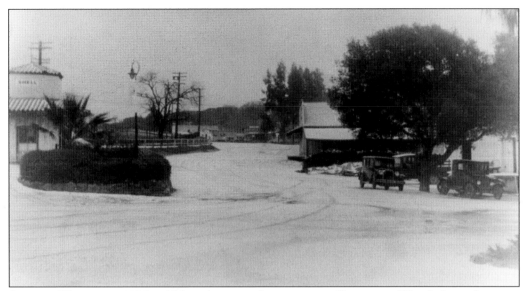

**SNOW IN WOODSIDE, 1930S.** Although rare, it does occasionally snow in Woodside, making it a cause for celebration rather than annoyance. This photograph shows the center of town with dirt roads turned to mud. Woodside's mild climate and protected location, nestled in the foothills, make it suitable for the "California lifestyle" of participation in numerous outdoor activities.

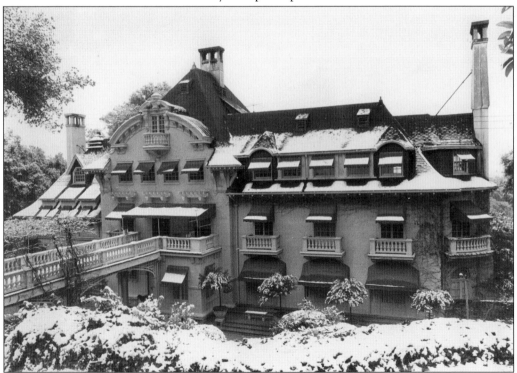

**FOLGER HOUSE IN THE SNOW.** San Francisco coffee baron James A. Folger's grandiose mansion shows a light dusting of snow. Woodside normally has mild winters and temperate summers, which made it attractive for "city folk" to escape the summer fog of San Francisco—many of them decided to build summer retreats here, most of which later became permanent residences.

JOHN GREER, 1808–1883. This Irishman was owner and captain of a ship that traded between South America and San Francisco. When his crew abandoned ship during the California Gold Rush, he explored the San Francisco Bay. Greer married Maria Luisa Soto Copinger, a descendant of one of the original Spanish settlers in this area.

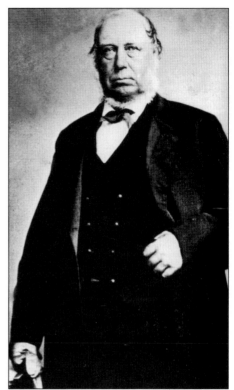

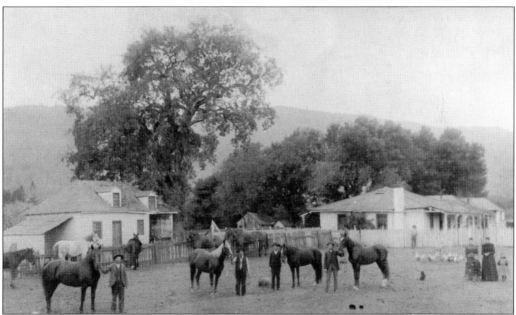

GREER HOUSE. Built in 1840, the adobe was near the corner of Kings Mountain and Woodside Roads. The original structure (at right) was destroyed in the 1906 earthquake, and the porch posts were reused to convert the granary to a house. Maria Copinger, who married John Greer after the death of her first husband, John Copinger, owned the land, which was part of Rancho Cañada de Raymundo.

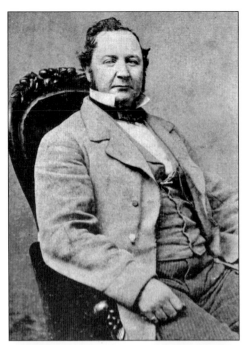

**CHARLES BROWN.** In 1828, at age 14, Brown deserted a whaling ship in San Francisco. Brown purchased a 2,880-acre ranch from John Copinger in 1846, cleverly paying for it with timber sales from the property. In 1847, Brown built the first sawmill on the San Francisco Peninsula, on Alambique Creek. The mill was water-powered, limiting its operation when water was not flowing sufficiently. In 1850, Brown unsuccessfully attempted to rename the area Brownsville.

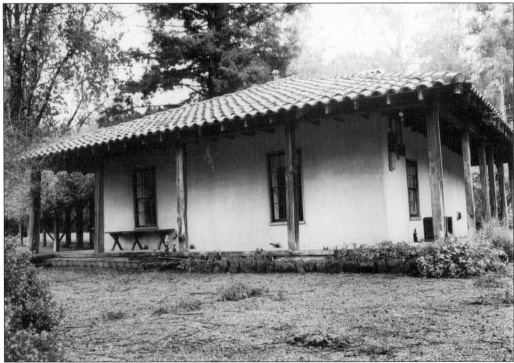

**CHARLES BROWN ADOBE.** Built in 1835, this is the oldest standing building in San Mateo County. Having survived several remodels, the adobe now appears more like the original structure. It was the site of many celebrations, including the wedding of longtime residents George and Katherine (Hooper) Somers. The adobe and surrounding property were later owned by the Schroll family and recently purchased by entrepreneur Tom Siebel.

# Two

# SAWMILLS AND SETTLERS

The influx of English-speaking settlers on the San Francisco Peninsula during the 1830s signaled the start of lumbering in the Woodside area. William Smith, known as Bill-the-Sawyer, arrived from Monterey in 1832 with a whipsaw, which increased the efficiency of the logging process performed by the Spanish. The Gold Rush of 1849 created a boom in building in San Francisco and a demand for lumber. The lumber, mostly redwood, was hauled by teams of oxen to the port in Redwood City and was floated north to build San Francisco, then called Yerba Buena, meaning "good herb."

Charles Brown purchased property from John Copinger, naming it Mountain Home Ranch. There he built the area's first sawmill in 1847 and an adobe house, which still stands along Portola Road. The lumbering industry flourished in the thickly wooded lower hillsides until the trees were depleted in the 1860s. Loggers passed through the settlement of Woodside on the way to new sawmills, often with a stop at Whiskey Hill—where they found water for the horses and whiskey for themselves. The sawmill operations were moved over the Coast Range (then called the Sierra Morena), toward the coast, clear-cutting the redwood forest along the way. The destruction was an ecological catastrophe, but second and third growth trees have replaced the giants that once stood there.

The lumbering industry gave rise to supporting industries, such as blacksmith shops, where "smithies" created wagon parts and horseshoes. Hubert Basset established Woodside's first blacksmith shop in 1867. These and other early settlers began raising families and forming a community of small farms and ranches near present-day Woodside.

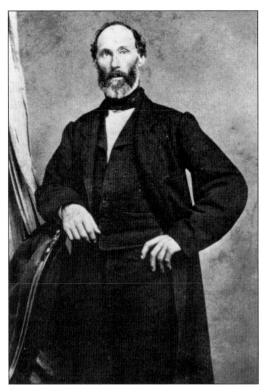

**Dr. Robert Tripp.** The early history of Woodside is intertwined with the life of Dr. Tripp. A dentist by trade, he came from Massachusetts to San Francisco and, in 1849, moved to the area now known as Woodside. Tripp partnered with Mathias Parkhurst and Charles Ellis to manufacture redwood shingles, and they discovered a place in Redwood City to float logs up the San Francisco Bay to assist in the building of San Francisco.

**Tripp Store, 1890s.** Recognizing the need for supplying goods to the area, Tripp and Parkhurst built a general store in 1851. The property consisted of 127 acres at the junction of Tripp and Kings Mountain Roads. The building also contained a post office (in 1854), a privately funded circulating library with 589 titles (in 1859), a bank featuring an armored safe, a dentist's office, a saloon, and a community center. Since 1940, the San Mateo County Historical Association has managed the store and site as a museum.

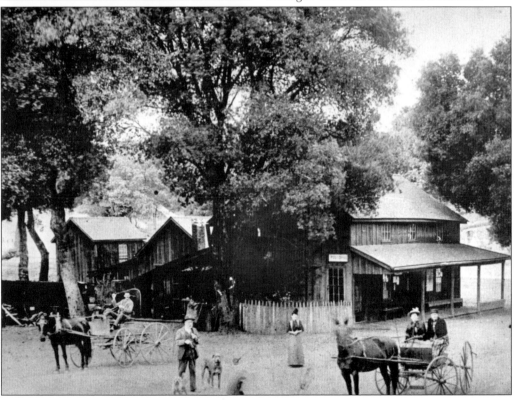

**TRIPP HOUSE.** Tripp built his house across the street from the store. He built a winery behind the store, which is now a private guesthouse. Tripp planted a small vineyard that produced a lovely Muscat wine, which he exhibited at the 1893 county fair. The bottle was labeled "San Mateo County Pioneer," with a drawing of a grizzly bear. The original house burned down in 1903, when an oil lamp overturned while Tripp's daughter, Addie, and her friends were singing Christmas carols at the piano. The house's replacement remains a private residence.

**CARRIAGE OUTSIDE TRIPP HOUSE, 1904.** Tripp lived in this house with his wife, Emeline Skellton, whom he met when she answered an ad for a housekeeper. One of their two children died young, and daughter Addie carried on the family tradition of providing the services of a community center at the store. At this single location, the Tripps sold lumberjack supplies, food, and clothing; distributed mail; lent books; and pulled teeth. Tripp died in 1909 at age 93.

**JOHN ALBERT HOOPER.** Hooper was a San Francisco financier who purchased the Mountain Home Ranch in 1883. That same year, he also bought a house near Mountain Home Road for use as a weekend retreat, which he named Rosedale Farm. Hooper lived on Rincon Hill in San Francisco with his seven children, and the family often spent weekends in Woodside. His grandson, John Hooper, later lived in town with his wife, Trish, where they raised their four children—Jock, Margot, Lawrence, and Helen. Helen later married US Congressman Pete McCloskey. (Courtesy Hooper family.)

**HOOPER HOUSE.** When Hooper purchased the Charles Brown adobe in 1883, it had a second story that had been added by the previous owner, Ephraim Burr. In the 1930s, Hooper restored the adobe to approximately the way it looked when Brown owned it. The structure still stands near Portola Road and continues to be known as the Charles Brown adobe. (Courtesy Hooper family.)

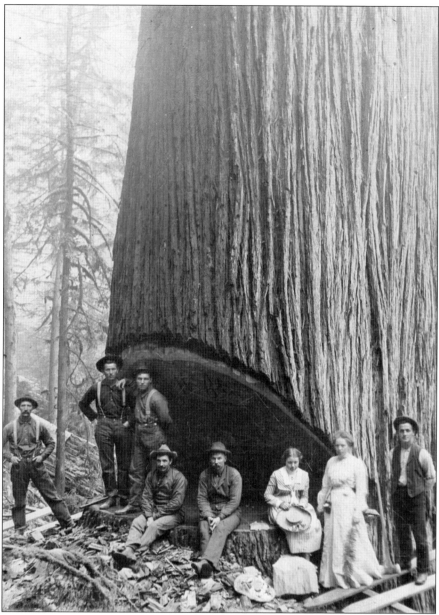

**FELLING THE TREE, 1904.** Redwoods are the tallest trees in the world, with some reaching over 400 feet. They are also among the oldest living plant species, with one recorded at 2,200 years old. This longevity justifies their Latin name, *sempervirens*, which means "everlasting." The range of redwoods runs from slightly north of the California/Oregon border to the southern part of Monterey County in areas with cool fog and precipitation, which provide for much of the trees' water needs. The Spanish expedition of 1776, led by Juan Bautista de Anza, scouted for lumber to build their missions and settlements. Early timber cutting was concentrated near the present junction of Kings Mountain and Woodside Roads. First growth giants like the one shown in this photograph were harvested without power tools. Logging continues in the surrounding mountains, though the second and third growth trees are much smaller. (Courtesy La Honda Historical Society.)

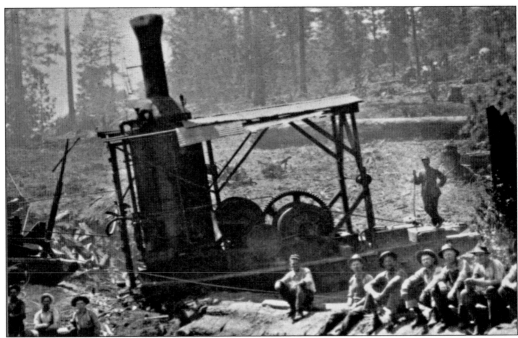

**DONKEY ENGINE.** This photograph shows an early stationary steam engine, representing a shift in technologies that by 1900 had replaced most oxen used to move logs. This second-generation donkey engine was used to drag logs to a landing by pulling them with a wire cable attached to a winch. (Courtesy Ken Fisher.)

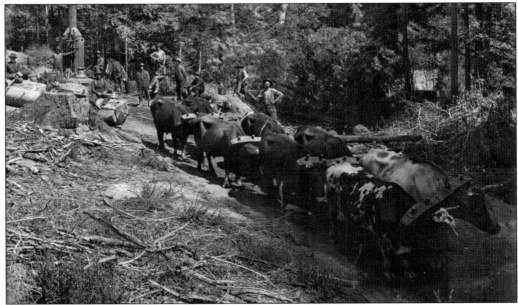

**HARTLEY-MCARTHUR SHINGLE MILL, C. 1904.** Hugh McArthur came to Woodside in the 1870s from Canada and owned a mill on Harrington Creek near La Honda. In 1883, McArthur joined other stockholders in the building of Independence Hall, which was to be used for public gatherings. McArthur's descendants continue to live in the original family home located near the Woodside School. (Courtesy Veliquette/Rice family.)

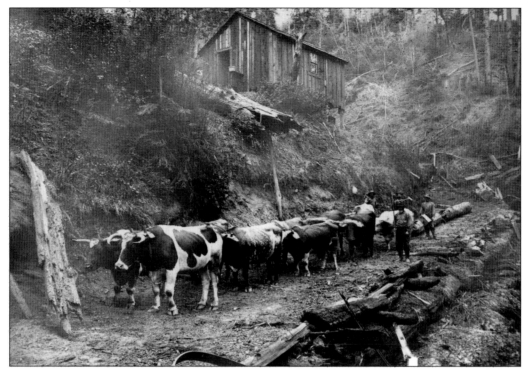

LOGGING TEAM, 1880S. This photograph shows the extent of environmental destruction, caused by early lumbering methods, that surrounded the Tacoma Mill near La Honda, including the erosion of soil from the hillsides and wood scrap left from clear-cutting the forests. Many of the original roads had gentle grades to make the trip easier for oxen pulling the huge logs down the hills to the docks in Redwood City. (Courtesy Redwood City Library.)

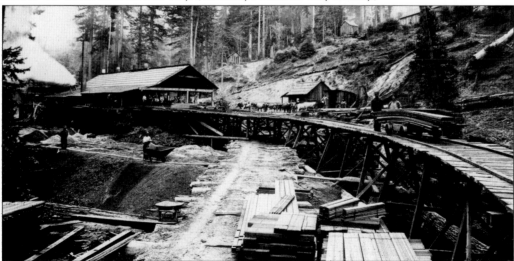

HANSON'S TACOMA MILL. By the end of the 1800s, most of the eastern face of the foothills surrounding Woodside had been logged. Lumbering operations moved west over the hills toward the coast, which required a three-day trip to the port in Redwood City. Frequent fires in San Francisco kept the mills active in providing lumber for new construction. The largest need for lumber occurred following the devastating 1906 earthquake. (Courtesy Ken Fisher.)

**WOODSIDE MILL, C. 1900.** This mill was located on the east fork of Tunitas Creek, west of Woodside. Photographs of sawmills near Woodside are rare because few cameras existed during most of the initial logging activity. By 1853, fifteen mills were active in the Kings Mountain area, producing over 20 million board feet of lumber annually. Improvements in milling methods, including the introduction of the circular saw, greatly increased lumber output. (Courtesy Ken Fisher.)

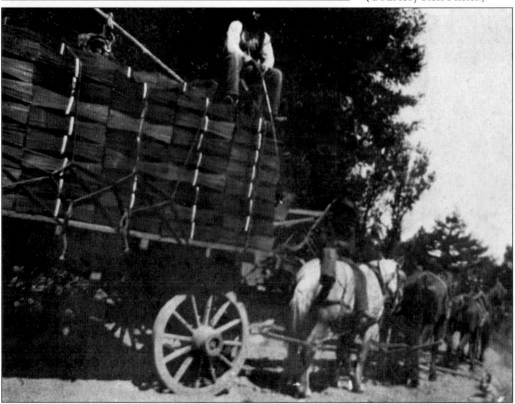

**SHINGLE WAGON, C. 1870s.** Redwood shingles were used for roofing, and later for siding, on buildings. Prior to the arrival of shingle-making machines, logs were cut into blocks and then split by hand into shingles and shakes. Workers were paid on a piecework basis. Packers stacked the shingles into bundles of 200. This photograph shows Joe Felix sitting on the shingles and Morris Felix driving the wagon to Redwood City. (Courtesy La Honda Historical Society.)

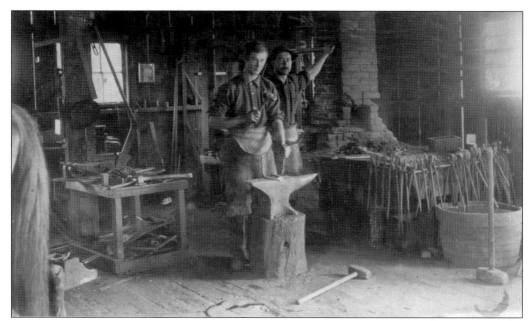

**WINKLER & SHINE BLACKSMITHS, 1869.** John Winkler has his hand on the bellows used to fan the fire that heated the iron. His son Fred is standing at the anvil with a hammer. The word "smith" originates from "smite," meaning "to hit." The iron or steel was hit while hot, shaping it into various metal parts used for wagons, carriages, and shoes for horse and oxen hooves.

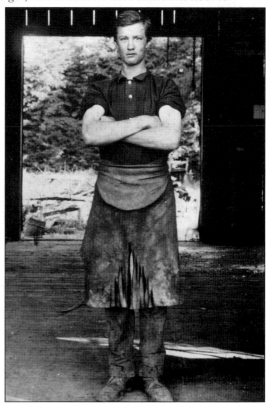

**FRED WINKLER, C. 1869.** Winkler wore a protective leather apron as he worked his trade in the Winkler & Shine Blacksmiths shop. This was dirty and heavy work but was a vital part of the commerce of the day, as it kept the wagons rolling and horses shod. A blacksmith's function was similar to that of today's automobile repair shops. Raymond Belmont and his son Louie took over the shop after George Shine retired.

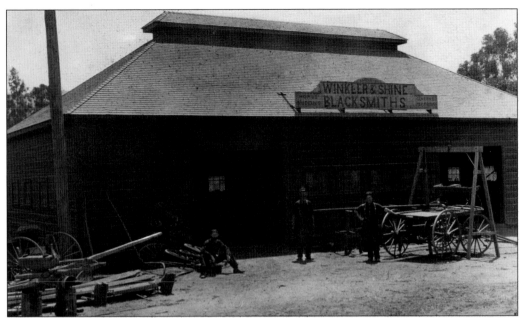

**WINKLER & SHINE BLACKSMITHS SHOP, EARLY 1900S.** The right entrance of the shop was for wagon carriages and wheel repairs, the left side for horseshoeing. As automobiles began replacing wagons, horseshoeing became the primary business of blacksmiths. This building was located on the south side of Woodside Road, just west of Whiskey Hill.

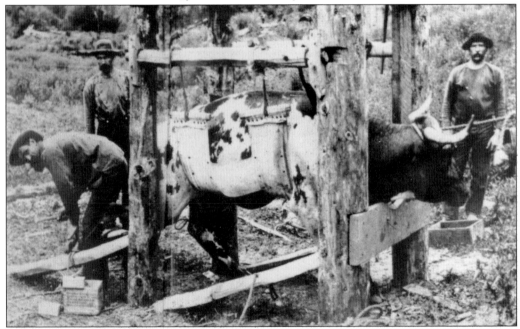

**SHOEING OXEN, LATE 1800S.** Retired blacksmith George Shine was once asked if he had ever shod an ox. He replied, "Yes, I did one, just to say I had, at McArthur's mill. Oxen couldn't walk over the rocky roads; they got sore-footed. In fact on those rough roads all shoes wore down fast." Unlike horses, oxen have cloven hooves, requiring a two-part shoe and making the shoeing task lengthier and more hazardous. The cradle restrained the unpredictable oxen. (Courtesy Ken Fisher.)

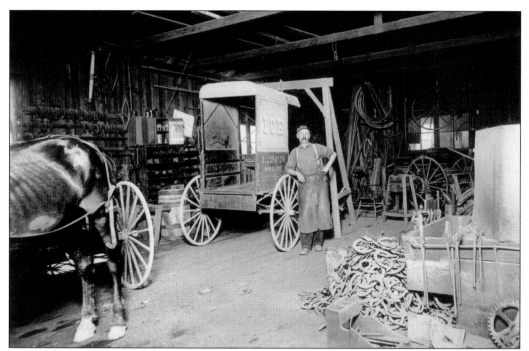

**ANDREEN BLACKSMITH SHOP, 1890.** Nils Andreen's shop was across from today's Pioneer Saloon when the area was known as Haakerville. In 1890, Andreen purchased this shop from John Brandrup. Andreen was also a wheelwright, forging the iron rims for wooden wagon wheels. The shop was condemned by the State Highway Department when the grade was changed on Woodside Road.

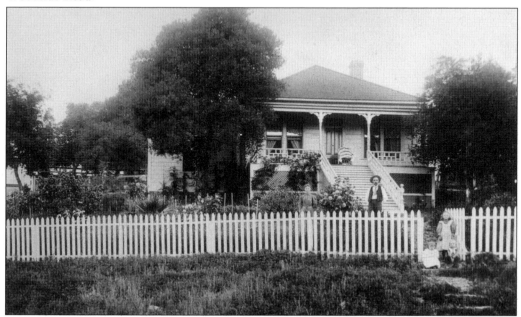

**NILS ANDREEN HOUSE.** Andreen is shown here with his wife, children, and an older neighbor girl (standing). In 1915, Andreen was one of two blacksmiths in town when the population was just over 200. The family home was conveniently located across from his shop on Woodside Road.

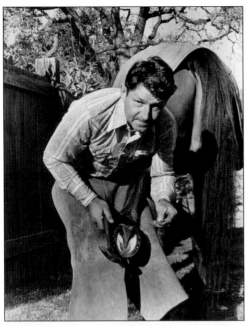

HAROLD ZWIERLEIN, 1994. Longtime resident Harold Zwierlein began horseshoeing after spending his youth as a professional bronc rider and steer wrestler, winning many awards on the national rodeo circuit. As one of several town farriers, Zwierlein reminisced about how much Woodside had changed over the years, but he credits the horse as being the enduring symbol of the town's rural character. Blacksmiths, including Jamie MacDonald and Butch Coggins, continue to make a living in Woodside. (Courtesy Sam Whiting.)

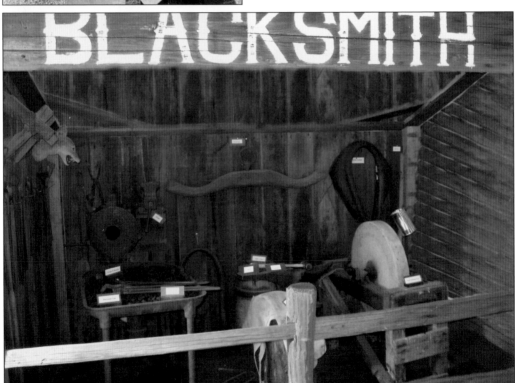

BLACKSMITH EXHIBIT, 2009. Harold Zwierlein, Jim Nance, and Rick Vaccaro built this re-creation of a blacksmith shop for an exhibit in the Woodside Community Museum. The display illustrated how metal was heated in a forge, where bellows blew air onto the coke coals. The blacksmith would then use tongs to grab and hold the hot metal on the anvil, where it was hammered into wagon wheel rims, horseshoes, farming tools, and other metal objects.

# Three

# STORES AND SALOONS

John Copinger made many improvements to his rancho, including constructing a gristmill and a dam on Bear Gulch Creek. He married Maria Luisa Soto, whose grandfather had accompanied the de Anza expedition to the San Francisco Presidio in 1776. In 1840, the Copingers built an adobe near the intersection of Kings Mountain and Woodside Roads, which was later destroyed in the 1906 earthquake. Following Copinger's death in 1847, Maria Luisa married Irish sea captain John Greer, and they became community leaders.

One of the earliest businessmen in Woodside was dentist Robert Orville Tripp, who came from Massachusetts in 1849 to recuperate from illness. He joined Mathias Parkhurst and Charles Ellis in establishing a sawmill near the present location of Woodside. Parkhurst and Tripp also opened a general food and supply store at the corner of Kings Mountain and Tripp Roads, calling it the Woodside Store, which is preserved as a California State Historical Landmark. Parkhust and Tripp were the first to call the surrounding area "Woodside." Tripp was a great contributor to the community.

Searsville was another lumbering community that developed near Woodside. Dennis Martin was an early settler there, arriving with the first wagon party over Truckee Pass in 1844 and later working at Sutter's Fort. He purchased land from Copinger, set up a sawmill, built his home, and planted orchards.

By 1890, lumbering could not sustain the town of Searsville. Spring Valley Water Company acquired the land and built a dam, which flooded the area and created a reservoir called Searsville Lake. Today, this lake and surrounding land are part of the Jasper Ridge Biological Preserve, which is owned by Stanford University.

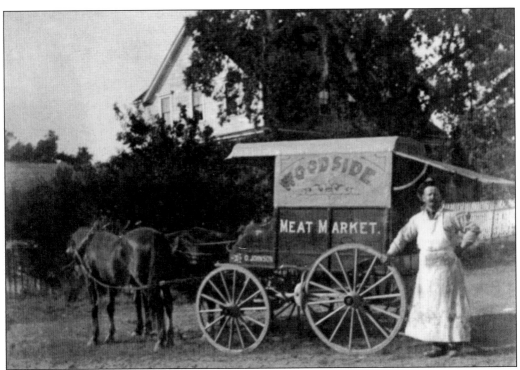

**WOODSIDE MEAT MARKET WAGON, C. 1900.** The original proprietors of the Woodside Meat Market were Olea Johnson and Nick Bozzo; Johnson bought out Bozzo in 1897. This photograph shows a wagon delivering meat to a customer. Without refrigeration, meat and other perishables had to be purchased frequently and stored in an insulated icebox in people's homes.

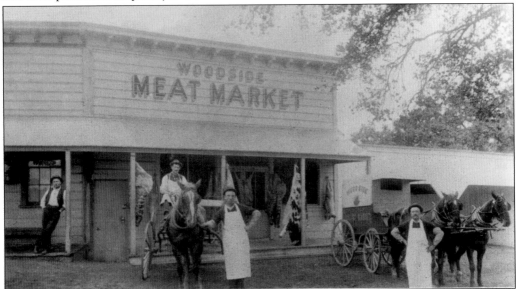

**WOODSIDE MEAT MARKET.** The original building housed a feed & fuel store managed by Irene Wilson and owned by Botchio Arata, who had a similar store in Redwood City. Sides of beef hang outside the market, ready to be butchered into various cuts. This structure was later converted into a general goods store.

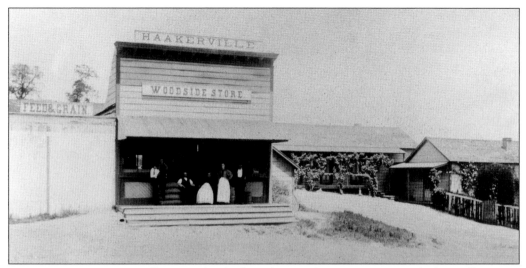

**HAAKERVILLE.** In 1880, William Haaker built a saloon and grocery store at Whiskey Hill Corner, near today's Pioneer Saloon. He hoped to name the area Haakerville, but the name didn't catch on. What did catch on was that this became the place to quench the thirst of loggers and teamsters travelling between Redwood City and the lumber mills. Haaker died in 1895 and was buried at Union Cemetery in Redwood City. The Pioneer Saloon carries on the tradition of Haaker's saloon—providing drinks, music, and dancing.

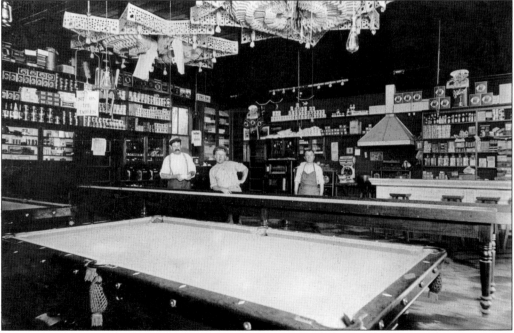

**INTERIOR OF WILLIAMSON STORE, 1913.** More than just places to buy dry goods, stores also served as community meeting places. Such rest stops were necessary for those making the arduous trek "down the grade" to Redwood City, a journey that was dusty in the summer and muddy in the winter. The cutout paper lanterns shown above the billiard table were popular ornaments of the era. The bar in the rear incorporated the original Live Oak saloon. Beverley Williamson Toombs recalls that there was always a glass pickle jar on the counter.

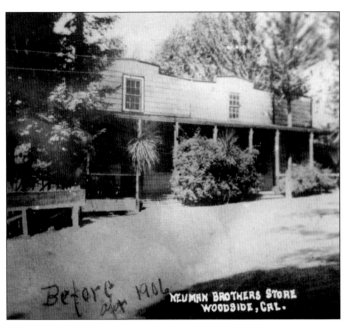

**NEUMAN BROTHERS STORE 1, 1893.** Andrew Neuman purchased part of the Charles Brown property in the 1870s. In 1893, with his brothers Arthur, James, and Grover, he opened a store located in a redwood grove south of Tripp Road, where Bear Gulch Creek crosses Woodside Road. Neuman's Grove, which opened with a grand picnic in May 1890, was also the site of the first May Day celebration in 1893. According to the *Redwood City Democrat* newspaper, "The grounds are the most attractive in the county. Beautiful walks, lovely flowers, good fishing . . ."

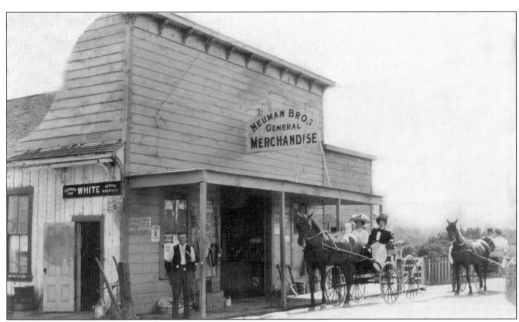

**NEUMAN BROTHERS STORE 2, 1907.** This store was located on the south side of Woodside Road, east of Mountain Home Road. The building that replaced this one was the original fire station for Woodside Fire District 1.

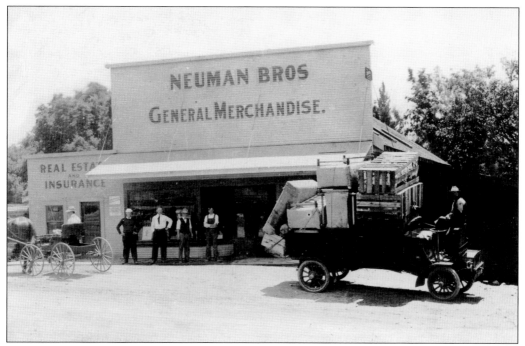

**NEUMAN BROTHERS STORE 3, C. 1908.** This store was near the southeastern corner of Mountain Home and Woodside Roads, where the Gilbert Center is now located. James Neuman was an engineer for San Mateo County who helped survey the layout for Woodside Road. This was a time of transition from horses to motorized vehicles.

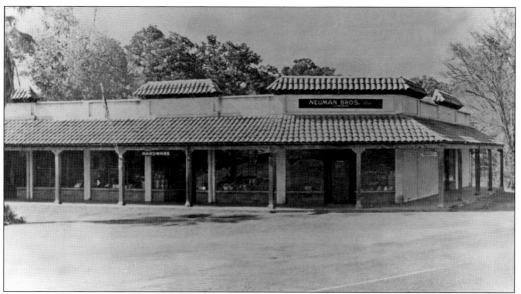

**NEUMAN BROTHERS STORE 4, 1930S.** This store was on the southwest corner of Mountain Home and Woodside Roads. James Neuman had two boys and twin girls, Marion and Barbara ("Bobbi"), who all helped run the store. Less than 25¢ bought a bottle of milk and a loaf of bread.

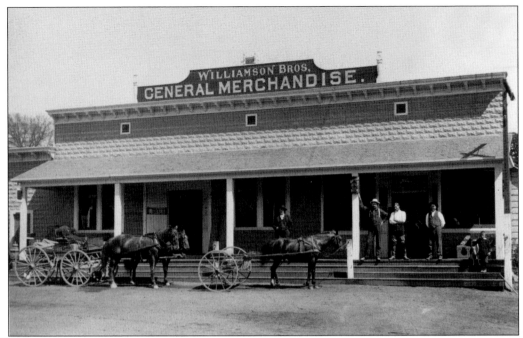

**WILLIAMSON BROS. STORE.** In 1902, John "Jack" Williamson rented the Haakerville Saloon, changing its name to Live Oak Saloon. The saloon was open 24 hours a day, selling three-ounce whiskey shots for 10¢ and quarts for 65¢. Wine was bought in wooden barrels from the local Rixford's Winery for 16¢ per gallon and used to fill bottles at the bar. In 1907, Jack and his brother William expanded the saloon to include a grocery store. Jack's son, Harry, is at far right in this image.

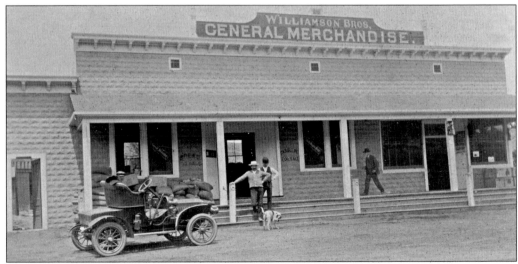

**WILLIAMSON BROS. STORE IN LATER YEARS.** Jack and William Williamson owned and operated the store until 1908, when Jack bought out his brother. Jack later leased the business to several people but bought back the lease in 1912, adding a lunch counter, pool tables, and a shuffleboard. Harry Hallett later leased the saloon, but was forced to close in 1918 because liquor establishments were not allowed within a five-mile radius of the Army's Camp Fremont, located in Menlo Park.

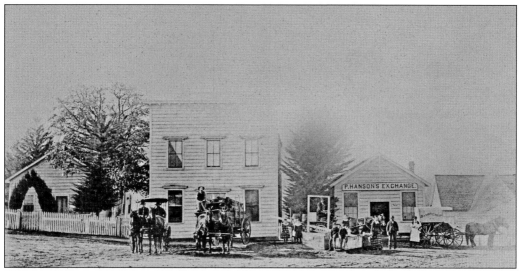

**HANSON'S EXCHANGE, 1884.** The first buildings were constructed on this site in 1878 and purchased in 1884 by Peter Hanson, who built the Pioneer Hotel. Cornelius Dalve rented the Pioneer Hotel until his Woodside Hotel was completed. The left side of the building behind the picket fence was a dance hall. In 1892, Peter Mathisen, who married Hanson's widow, became manager of the Pioneer Hotel.

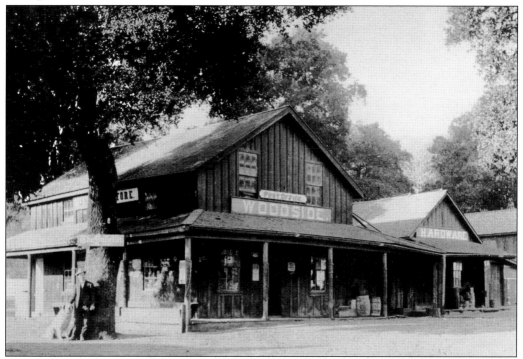

**TRIPP STORE.** Dr. Robert Tripp was elected to the first San Francisco County Board of Supervisors in 1850, before the county of San Mateo was established in 1856. He rode his horse to the meetings in San Francisco each Monday and returned the next day, a distance of about 70 miles round-trip. Tripp charged $4 to extract a tooth at his store, compared to $16 for an extraction in San Francisco. The store sold coffee for 20¢ per pound and soda crackers for 13¢ a pound.

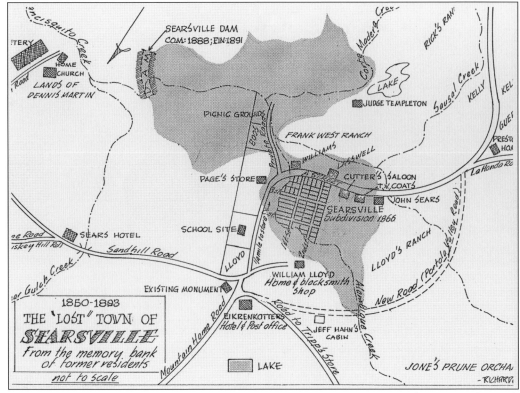

**SEARSVILLE.** The community of Searsville was located south of Sand Hill Road, near Portola Road. The settlement grew up around a house built in 1854 by mill owner John Sears, a prominent citizen in the community. In 1862, he moved to the town of La Honda, west of Woodside. Contrary to this map, much of the town was not flooded when the original dam was built in 1891. (Courtesy Gilbert Richards.)

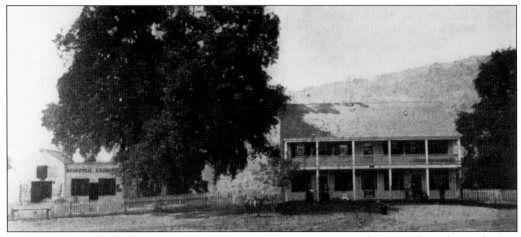

**EIKERENKOTTER INN, SEARSVILLE.** Prussian immigrants August and Lena Eikerenkotter built a hotel, restaurant, store (Searsville Exchange), and post office in the 1850s. George Shine recalled, "It was the scene of genuine western activities—gambling, horseracing and wrestling . . . One time a fellow was caught cheating at cards. When he reached for the pot someone put a knife right through his hand." The Eikerenkotters moved to Redwood City in 1889.

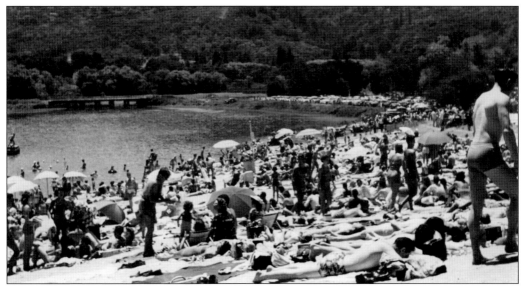

**SEARSVILLE LAKE.** The spirit of Searsville was dying with the declining lumber industry. In 1891, the Spring Valley Water Company convinced a court that the Searsville basin needed to be flooded to store water for San Francisco. Work began on the dam in 1888, and in 1891 the area was flooded and residents were forced to move. This lake was a popular summer recreation area from the 1950s to the 1970s.

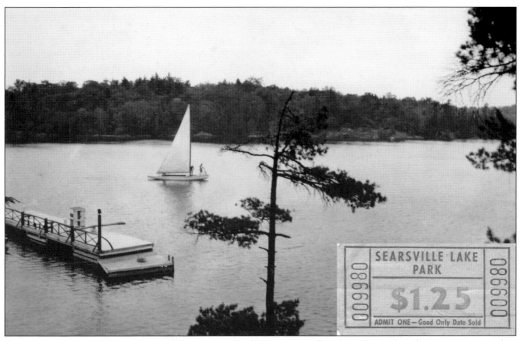

**SEARSVILLE LAKE PARK.** Leased from Stanford University by the Clapp family, activities at this recreation park included boating, a bicycle track, and horse trails. Austin Clapp won a gold medal in a swimming relay with Johnny Weissmuller in the 1928 Olympics. After the area was closed in 1975, it became the Jasper Ridge Biological Preserve. Public access is restricted, with docent-led tours of the research facility and nature trails.

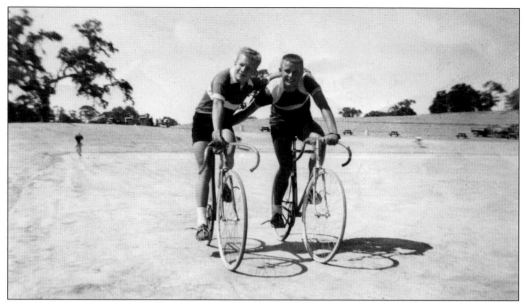

SEARSVILLE BICYCLE TRACK, 1957. Nick Van Male (on left) and Peter Rich are shown at the one-sixth-mile banked oval track at Searsville Lake. Built by the Clapp family in 1956, the track was used for informal racing during 1956 and 1957. It was never paved, and its unstable dirt surface kept it from becoming popular. The track is still visible near the road to the Jasper Ridge Field Station. (Courtesy Peter Rich.)

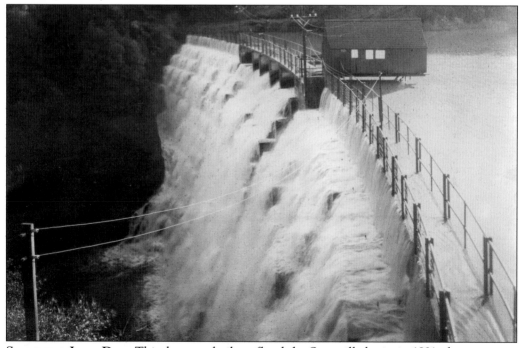

SEARSVILLE LAKE DAM. This dam was built to flood the Searsville basin in 1891, the same year Stanford University was established. The dam's original 60-foot height was raised seven feet in 1919. The reservoir's capacity has been diminished by silt because of stream runoff from the surrounding hills, and there is a present-day movement to remove the dam.

**SEARSVILLE HERMIT.** Dominico Grosso was known as Domingo, the hermit of Jasper Ridge. Rumored to be from Genoa, Italy, he arrived in the area in the 1870s after spending time mining in Chile. He reopened the nearby Nicolas Larco silver mine in 1891 and was a master winemaker. He lived alone on land that is now Jasper Ridge Biological Preserve until his death in 1915.

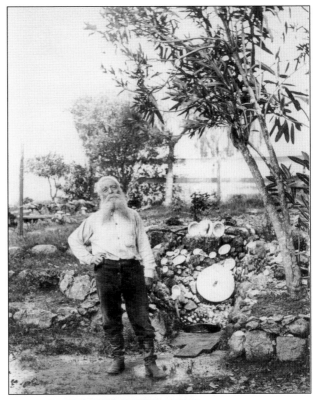

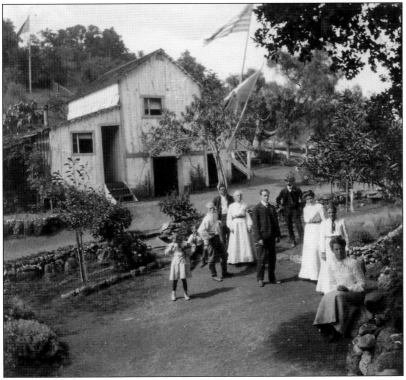

**HERMIT'S HOUSE.** The hermit's house was rustic, but well furnished and clean, surrounded by a vineyard, orchard, and flower and vegetable gardens. The hospitable "hermit" received many guests here, including Stanford students and even Jane Stanford herself. He would serve his homemade wine, special bread, biscuits, and wild game for dinner.

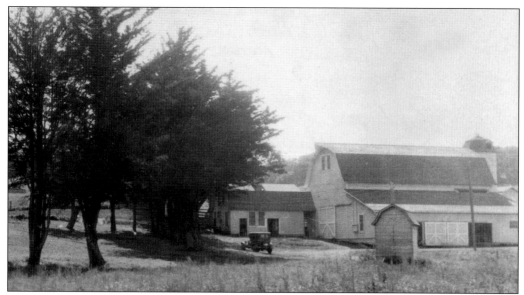

**GILMAN'S MODEL AYRSHIRE DAIRY.** This was one of the first mechanized milking dairies in the country. Vermont transplants James and Leila Gilman purchased 63 acres of the original Rancho Cañada de Raymundo in 1921 and built barns with cork floors and steel pens. In 1946, the Gilmans divided and sold the property, part of which was purchased by the Rosekrans family. The barn became Cañada Riding Stables and a portion was later converted to a private residence.

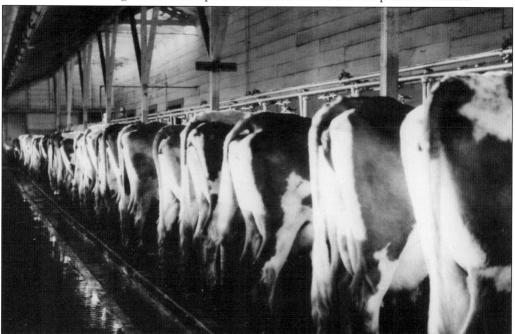

**AYRSHIRE HERD.** This Scottish breed was selected by dairy industrialist James Gilman. With 170 purebred cows, this was the largest Ayrshire herd on the West Coast and it won many prizes. Known for their rich milk, the cows are productive and attractive—mostly white with distinctive red markings. Gilman exclusively used the DeLaval milker and cream separator, and distributed the milk in glass bottles to San Francisco Peninsula communities by truck.

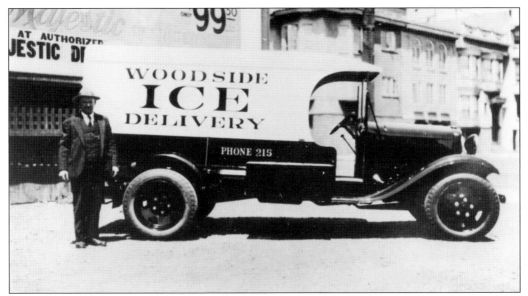

**WOODSIDE ICE DELIVERY TRUCK.** Prior to the invention of electric refrigerators, food was kept cold in insulated iceboxes, which had a compartment for a block of ice and a drain for the melting water. Ice was cut into 50-to-100-pound blocks and delivered regularly to homes by insulated trucks. Ice was sold for 1¢ per pound, delivered.

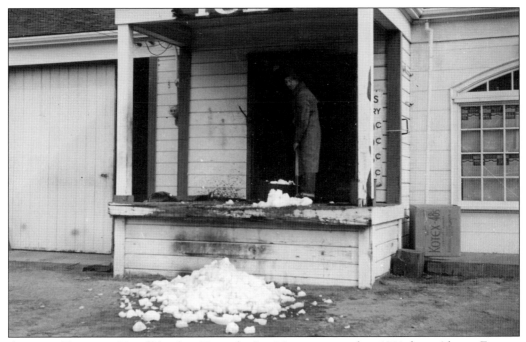

**ANTOINE ZAEPFFEL.** Zaepffel, a.k.a. Tony the Ice Man, emigrated in 1911 from Alsace, France. He married his French wife, Elise, in San Francisco, and they had five children. He began his ice business in Redwood City and later moved to Woodside, which reminded him of his homeland. Zaepffel also owned the first gas station in Woodside. His icehouse was adjacent to the Williamson Bros. store on Woodside Road.

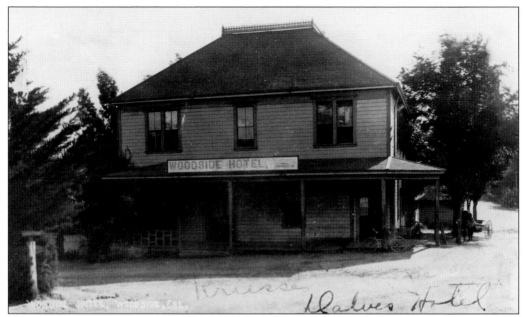

**WOODSIDE HOTEL, 1892.** Cornelius Dalve built a hotel near the intersection of Mountain Home and Woodside Roads. The building fell into disuse between the end of the logging boom and the subsequent popularity of Woodside as a summer vacation spot. The roads were unpaved, and the bicycle in front of the hotel shows a popular form of transportation of the time.

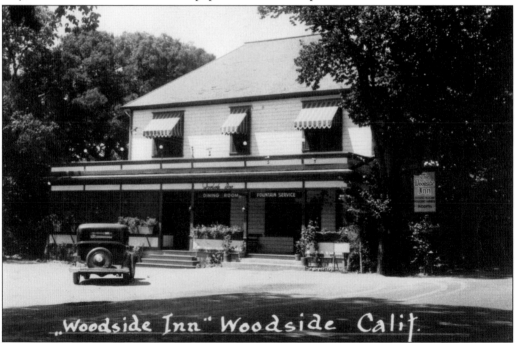

**WOODSIDE INN.** After being refurbished in the early 1900s, the Woodside (Dalve's) Hotel was reopened as the Woodside Inn, owned and operated by the Gustav Seebohm family. It was moved in 1926 to the western edge of the property, near Dry Creek, to make room for the fourth Neuman Bros. store. The inn was also used as lodging for some store employees.

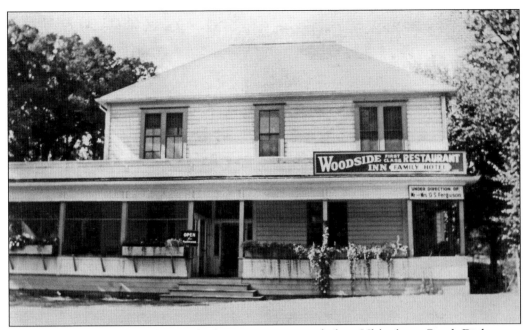

**WOODSIDE INN, 1930S.** The Inn had many owners, including Uhlenberg, Reed, Dickerson, Nicodemus, and Ferguson. It was purchased by the Neuman brothers in 1915 after their family home was destroyed by a fire. The town library was located in a room on the right side in the 1940s after the inn was closed. When James Neuman demolished the inn, he used parts of the building for an addition to his home on Neuman Lane.

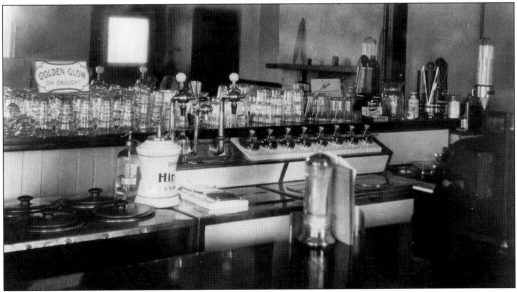

**WOODSIDE INN SODA FOUNTAIN.** Soda fountains were popular from the 1930s to the 1950s, especially as a place for teenagers to meet with their friends. Elsa Mueller managed the fountain, which served ice cream sodas, hot fudge sundaes, and milkshakes made to order from a variety of flavors. The servers were usually young boys, known as soda jerks, who typically wore white uniforms and paper caps.

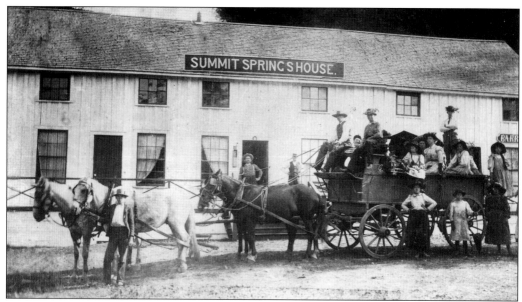

SUMMIT SPRINGS HOUSE, 1892. Built midway between Redwood City and Eugene Froment's lumber mill in Tunitas Canyon, Summit Springs included a saloon, a store, a blacksmith, and a stable. Since 1869, it had been used as a health resort known for its water, climate, and scenery. In 1891, the *Times Gazette* declared, "The purity of the waters of the springs which abound here cannot be excelled, and there are numerous sulphur, iron and other mineral springs on this tract of land." (Courtesy Crosspoint Venture Partners.)

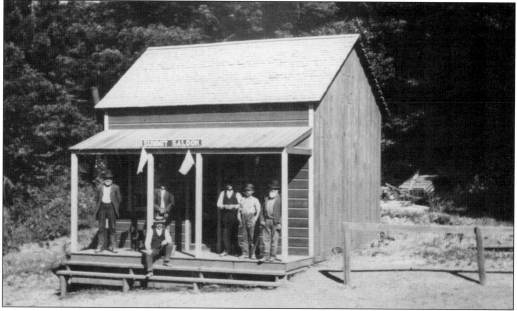

SUMMIT SPRINGS SALOON, 1898. Located near Skyline on Old La Honda Road, this destination was an important halfway stop en route to the coast. It offered drinks for weary loggers and a watering trough for thirsty horses. John Sears, the founder of Searsville, owned the saloon, along with Albert Eikerenkotter, shown standing second from left. The US flags are being flown to celebrate July 4th. (Courtesy Charlie Catania.)

# Four

# TRAILS AND TURNPIKES

An early route originally blazed by the Costanoans linked San Gregorio with the San Francisco Bay. It was later called the Old Spanish Trail, and is now Alpine Road. Transporting lumber from the sawmills near Woodside down to the docks in Redwood City required better roads. Many of these began as "skid roads" used for dragging redwood logs through the forest via teams of oxen. Later, stagecoach service transported people over the Sierra Morena mountains on narrow dirt roads like the Searsville–La Honda turnpike, which is now Old La Honda Road. Passengers often had to disembark so that the stagecoach could proceed through the steepest sections. Part of the Searsville road connected to Sandy Hill Road, now Sand Hill Road, which was used for dragging logs to Mission Santa Clara.

Today's Kings Mountain Road was part of the San Gregorio Turnpike, built in 1870. The road was narrow and the horse teams wore harness bells to warn oncoming teams so that one of them could pull off the road to pass the other. Wooden bridges were constructed across major creeks; these were later replaced with concrete bridges.

Clusters of businesses and residences began to develop along these routes at major intersections like Searsville and Whiskey Hill. The Pioneer Hotel and Woodside Inn on the Whiskey Hill stagecoach route provided a rest stop for people to spend the night on the two-day journey to the coast. The Neumans built their first grocery store in 1893 along the Redwood City–Pescadero route, today's Bear Gulch Road.

Many generous donors in Woodside have contributed land that is now preserved as open space. Public parks like Huddart and Wunderlich offer tranquility and rustic trails for both pedestrians and equestrians to enjoy.

**KINGS MOUNTAIN ROAD.** Named after Frank and Honora King, this road was built in 1870 as one of the first routes over the mountain to the coastal town of San Gregorio. The Kings ran a saloon and later a boarding house, providing food and lodging to travelers. Their compound was on land belonging in part to the Greer family, who sued the Kings for ownership in 1888. The Kings lost the lawsuit but were still awarded 30 acres.

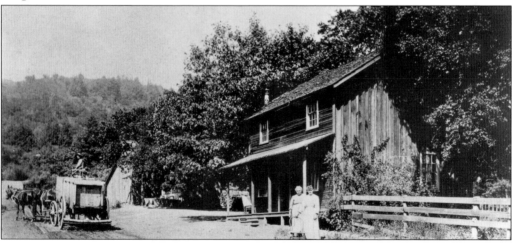

**SUMMIT SPRINGS TOLLHOUSE, 1873.** Summit Springs Road, Tunitas Creek Turnpike, and San Gregorio Turnpike were toll roads, charging 15¢ for a saddle horse, 25¢ for a horse and buggy, and two and a half cents for sheep, hogs, or goats. Travel from Redwood City to the coast took two days. The *San Mateo County Gazette* stated that the abandoned sawmills that remained after logging were a reminder to passersby of "the industry that in time ago gave thrift and prosperity to the burgs of Woodside and Searsville." Catherine (left) and daughter Lucy Bottger are shown in front of the tollhouse, which was also used for boarding overnight travelers.

**KNIGHTS STAGECOACH, 1869.** Simon Knights bought the Redwood City–La Honda stage line from David Garland in 1866. Knights parked the coach behind his home, which still stands on the northeast corner of Albion Avenue and Woodside Road. His 17 coaches were made by blacksmith Leonard Fisher and wheelwright S.N. Murch. The stage line operated for over 40 years, carrying passengers and mail. It was replaced by Pierce Arrow motorized stages.

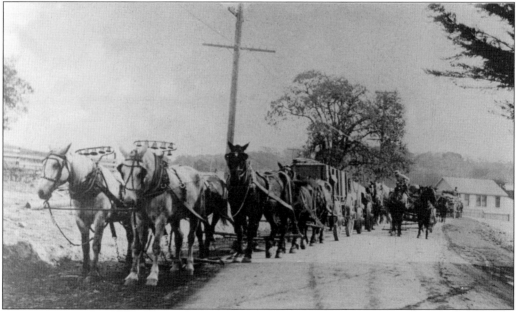

**SUPPLY WAGON, C. 1900.** This supply wagon served the communities of Woodside, La Honda, and San Gregorio. These wagons supplied the necessities for daily life to people who were not able to make frequent trips for groceries or dry goods. The bells on the lead horses were used to alert oncoming wagons so that they could move aside to pass on the narrow roads and thus prevent "pioneer road rage."

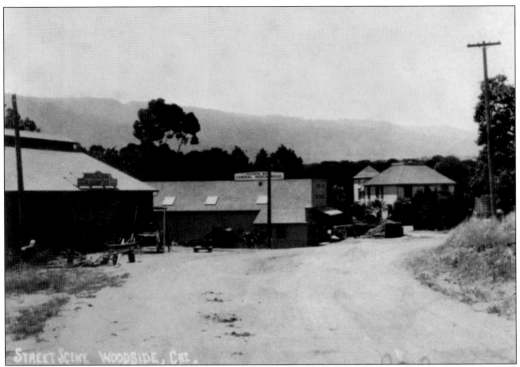

**WOODSIDE "STREET" SCENE, 1912.** This photograph shows Woodside Road, looking west from near Whiskey Hill Road. The closest building is the Winkler & Shine Blacksmiths shop, next to it is the third Neuman Bros. store, and farthest away is Dalve's Woodside Inn, located on the present-day site of Roberts Market.

**SAND HILL ROAD.** Near Searsville, Sand Hill Road (then called Sandy Hill Road) was used for dragging logs to Mission Santa Clara. The road, a major link from Stanford University and Palo Alto to I-280, is now the epicenter for offices of many Silicon Valley entrepreneurs and venture capitalists, some of whom live in Woodside.

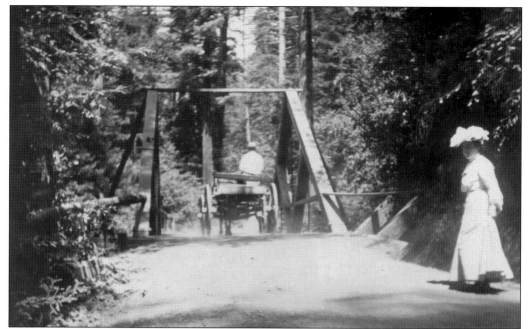

**WOODEN BRIDGE, C. 1910.** Bridges such as this one were a necessary part of the early transportation system in the area. People like Henry Bottger were known for their skill in building structures sturdy enough to support wagons full of people, supplies, and lumber. When the load was too heavy for the bridge, passengers had to get off the wagon and walk across before continuing their journey.

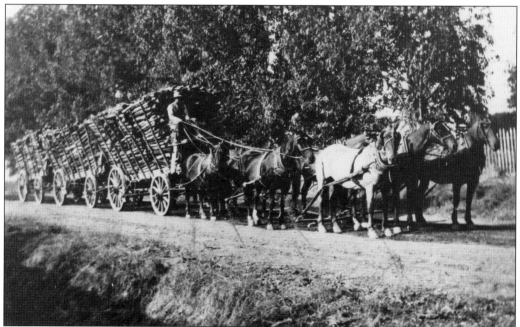

**TAN BARK WAGON.** The bark from tan oak trees was used in tanning cowhides to soften the leather, which was then made into clothing, shoes, saddles, and other articles. Bill Shine is driving this wagon and most likely going to Frank's Tannery in Redwood City.

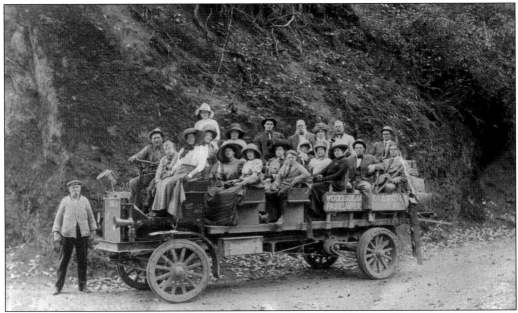

**WETHERBEE'S MOTOR STAGE, 1915.** Al Wetherbee is at the wheel of his Gramm motor stage, which provided transportation between Woodside and coastal communities. Able to carry 22 passengers, plus the driver and freight, this truck had a chain drive and hard rubber (not pneumatic) tires, which made for a long, rough, and dusty ride over the mountains. Motor vehicles put a quick end to horse-drawn stagecoach service.

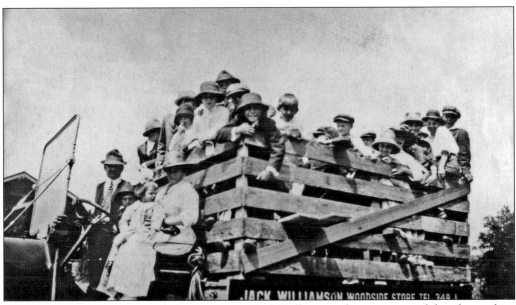

**DELIVERY WAGON, 1915.** Woodside Store owner Jack Williamson drives a group of church members in his delivery wagon to a picnic at the Huddart estate. The Huddart sisters were Sunday school teachers at the Woodside Village Church, and they organized picnics and children's activities at their property, which later became Huddart Park.

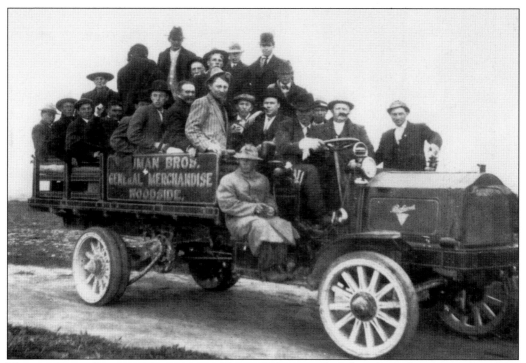

**NEUMAN BROS. GENERAL MERCHANDISE TRUCK.** When people did not have their own automobiles to go shopping every day, vehicles like this Packard truck were used to pick up goods for the store from suppliers and to deliver groceries and merchandise to local households.

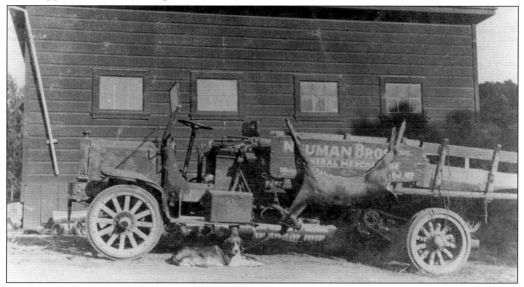

**EARLY NEUMAN BROS. DELIVERY TRUCK.** The Neuman twins, Barbara ("Bobbi") and Marion, who ran the store in the 1950s, told many tales of interesting encounters they had while using their station wagon to continue the tradition of delivering groceries to customers' homes, often through unlocked back doors. Bobbi Neuman recalled that deliveries were double-checked so that C&H sugar was not delivered to the Spreckels estate and that Hills Brothers coffee was not delivered to the Folger estate.

GRACE ANDREEN. Andreen sits in a Flanders car in front of the Andreen Blacksmith Shop. Flanders was a Detroit automobile manufacturer that operated from 1910 to 1913. Walter Flanders helped invent the ingenious manufacturing methods that made the Model T Ford so popular. In 1908, Flanders left Ford Motor Company and started his own automobile company. By about 1920, the steering wheel location had been standardized to its current placement.

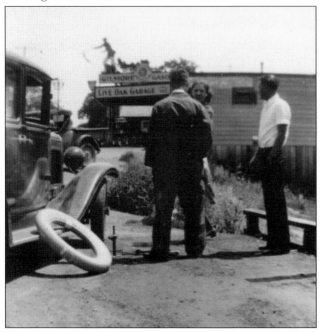

FLAT TIRE, 1930s. Automobiles became popular when many roads were still unpaved and uneven, often presenting many hazards to soft rubber tires. In the background, along Woodside Road, is Live Oak Garage, which became Gayle Shine's coffee shop in the 1940s. Gilmore Oil Company (1900–1945), provider of gasoline for Live Oak Garage, later became Mobil Oil Company. The man pictured here in the white shirt is Alvin "Tick" Hallett, and the woman is Nellie Skrabo, who later married Tom Shine.

**RED CROWN GASOLINE STATION, 1919.** This station was located on Woodside Road, across from Whiskey Hill Road. All Standard Oil Company gasoline was sold under the brand name of Red Crown prior to its breakup into 33 separate companies in 1911. However, the Red Crown image continued to be used for another 50 years. Antoine Zaepffel owned the first Woodside gas station, which also sold groceries, candy, soda water, and ice cream.

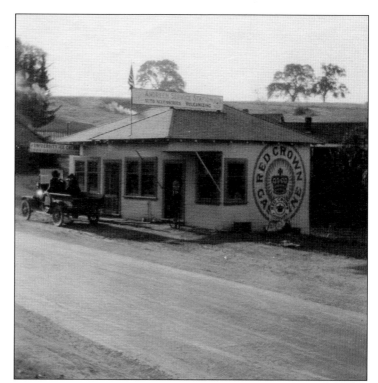

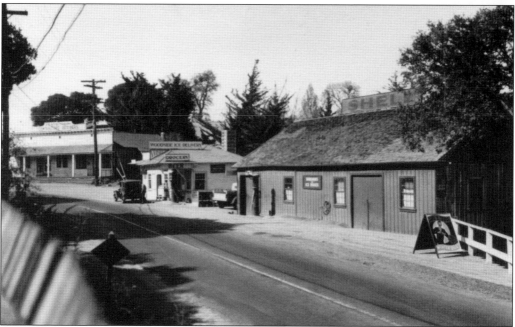

**WOODSIDE ROAD, C. 1930s.** This image was captured from the southeast corner of Whiskey Hill on Woodside Road. The building on the left originally housed Palmtag-Leoni Contractors & Builders, and later the Williamson Bros. Store. In the middle is Woodside Ice Delivery, owned by Antoine "Tony the Iceman" Zaepffel. The cooling tower behind the building was used for ice production. Andreen's Blacksmith Shop, on the right, also sold gasoline.

SHELL GASOLINE STATION, 1936. This station was formerly Andreen's Blacksmith Shop. A natural transition occurred from blacksmithing to auto repair as horse-drawn carriages were replaced by automobiles. The Shell sign on the white fence shows the direction of Woodside Road today. The gulch was filled and the road was straightened and widened to accommodate motor vehicles in the 1940s. In the background is Lee Beck's Market, which delivered meat to feed the lions and other exotic animals that belonged to eccentric resident George Whittell Jr.

CAR IN CUT TREE, 1920s. Many of the local roads were unpaved and barely drivable, especially during rainy weather. Note the diameter of the fallen redwood, which had to be cut to allow access to the road. Estimated at over 200 years old, such a tree would normally be converted into lumber, unless it was inaccessible.

SHELL GAS STATION. This gas station was located in the small triangle within the intersection of Woodside and Cañada/Mountain Home Roads. This station was owned by Jim Neuman, son of the owners of the nearby Neuman Bros. Store; it was later converted into a barbershop. In the 1950s, the station had the first Coca-Cola vending machine in town.

CHEVRON GAS STATION. The Shell gas station was later reopened by Standard Oil Company. Boys were instructed to use the women's restroom on the south side because cars running the stop sign at Cañada Road occasionally ran into the men's restroom on the north side. The building was demolished in the 1970s in order to widen Woodside Road. The triangle was named Alexander Donald Park to honor Woodside's first road commissioner.

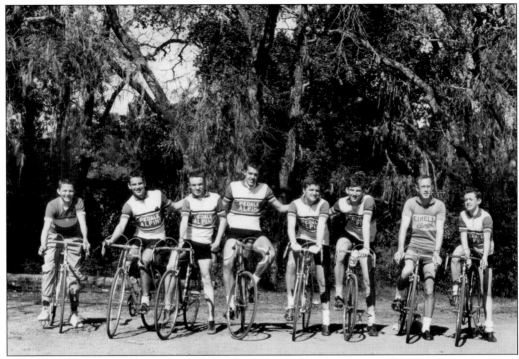

**PEDALE ALPINI BICYCLE CLUB, 1957.** When American bicycle racing was close to disappearing and those still racing were riding fixed-gear bikes, this group began meeting in Woodside. Adopting 10-speed bicycles, they pioneered a new American interest in road racing. Without coaches or sponsors, this group placed three riders, including George Koenig (fifth from left), on the 1960 US Olympic Team. These racers began a movement that made possible the current international success of American cyclists. This photograph was taken where "Woody the Fish" currently stands next to Buck's Restaurant. (Courtesy Larry Walpole via Howard Hickingbotham.)

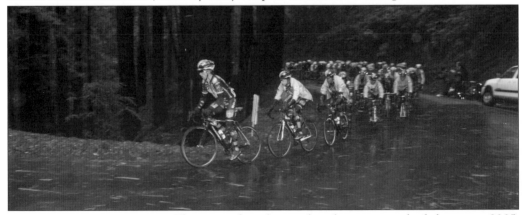

**TOUR OF CALIFORNIA, 2008.** This annual professional cycling event, which began in 2005, has included several routes through Woodside's winding roads. Organized cycling in Woodside started in 1897, when a group of local cyclists met for the purpose of forming a club. Members included residents Neuman, McArthur, Shine, and Horton. Cycling continues to be popular in the area. Woodside residents Dawn Neisser and John Novitsky are national champions in their classifications, and Lindsay Crawford won the over-60 group stage of the 2003 L'Étape du Tour in France. (Courtesy Mike Piper.)

# Five

# THE TOWN GROWS UP

John Greer and his wife, Maria Luisa Soto, donated land for the first schoolhouse in the area in 1851, naming it Greersburg Elementary School. The name was changed to Woodside Elementary School in the 1950s. The building was moved and renovated in 1989 and now serves as the school library, located on Woodside Road.

The first lending library was part of the Tripp Store. From 1927 to 1946, the library was located in the Old Red Schoolhouse and later moved to the Woodside Inn. The current library, on Woodside Road, opened in 1969.

Since there was no organized fire service, volunteer citizens were needed to help extinguish fires. In 1925, the Woodside Fire District was formed, setting boundaries of the area to be served and levying a tax for a fire station and equipment. Firefighters remained volunteers until 1929. The fire department added paramedics to their crews in 1994. The Citizens Emergency Response and Preparedness Program (CERPP) coordinates citizen groups in preparing themselves for emergency situations, and it was awarded the James V. Fitzgerald Award in 2000 for its high degree of collaboration between agencies.

Woodside Village Church Chapel was built across from the school in 1893. The land cost $200. Dedicated in 1893, it served as a branch of the Redwood City First Congregational Church. A larger congregational church, now affiliated with the United Church of Christ, was built in 1961.

A corporation of local citizens built Independence Hall for hosting public affairs in 1884, and after being moved three times, the building is now the town's meeting hall.

The first post office was opened at the Woodside Store in 1850, with Dr. Tripp serving as the first Postmaster. From 1909 to 1915, the post office was located in front of the Jenkins House on Woodside Road. The town then had no post office for over 35 years, until it reopened in 1953 at Holt's Country Store near Whiskey Hill.

The first grocery was at the Tripp Store, followed by the opening of the first Neuman Bros. store in 1893. Much growth occurred in the area during the 1920s, and with it came an increasing sense of community. Woodside had everything a real town was expected to have—a school, a fire district, a library, and a church. The town had grown up.

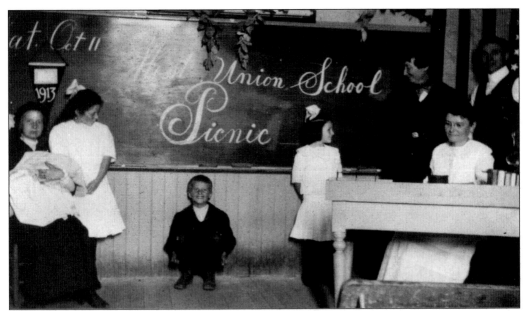

**WEST UNION SCHOOL CLASSROOM INTERIOR, 1913.** West Union was a small community located north of Woodside, its location marked by a plaque near the intersection of Cañada and Edgewood Roads. Built in 1861 for nearly $600, this typical one-room schoolhouse had students ranging from 5 to 18 years old, which made a single lesson plan difficult. Attendance was seasonal, as students were often needed at home to help with family chores or farming. The building burned in 1876 and was rebuilt the following year.

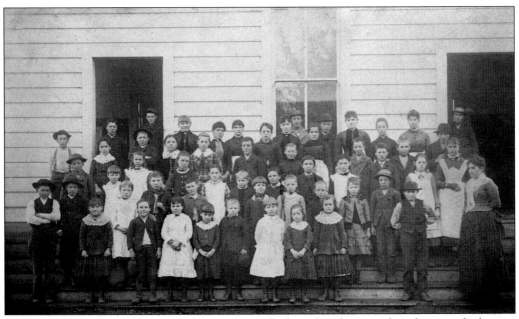

**WOODSIDE ELEMENTARY SCHOOL CLASS, 1886.** The list of students in this photograph shows a number of familiar Woodside family names, including Miramontes, Shine, McArthur, Bottger, Winkler, Hallett, Knights, and Kelly. Built in 1877, this school building is the oldest in San Mateo County. In 1989 it was moved and renovated as the Woodside Elementary School Library.

**EARLY WOODSIDE SCHOOL.** The first school was named Greersburg Elementary School, built on land donated by the Greer family in 1851. The original building was an addition to the Ruben Taylor family home on Woodside Road. The class of 1859 had 112 students. In 1876 the Greers dedicated a second site for a "proper" schoolhouse. Soon other schools sprung up in the area, including West Union in 1861, Searsville in 1859, and Summit Springs around 1880.

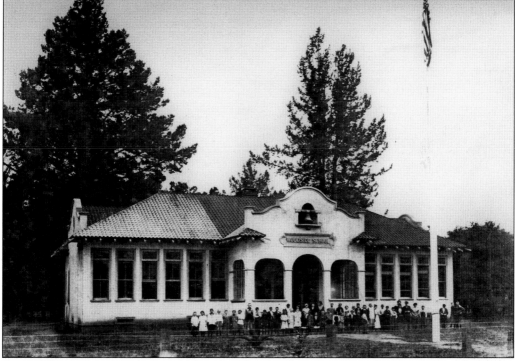

**LATER WOODSIDE SCHOOL, 1915.** Although early schoolhouses in the area were one-room buildings, the 1910 Woodside School was a larger, multi-classroom structure built in the Mission Revival style of architecture. Deemed to be seismically unsafe, this building was demolished in 1964. Its replacement was also demolished in 2007 as part of a campus renovation. The bell shown at the top of the building is in the courtyard of the current school.

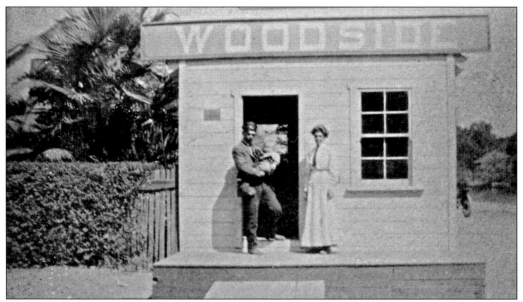

**JENKINS POST OFFICE, 1910.** After the post office at the Tripp Store closed, Andrew Neuman became postmaster at his store near Bear Gulch in 1886. The post office later moved to the front of Henry Jenkins' property on the corner of Woodside Road and Albion Avenue. This building was torn down in 1915, when it was decided that the town did not have enough residents to support a post office. The adjacent Jenkins home, built in 1889, remains at that location and was renovated in 2001 by the Wood-Fitzpatrick family.

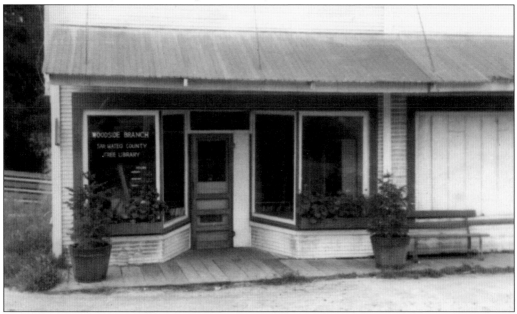

**EARLY LIBRARY.** The first circulating library in San Mateo County began in 1859 at the Tripp Store with the help of the Woodside Library Association. When it opened, 190 volumes of literature were purchased at a cost of $212.14 and lent to subscribing members. This library was later moved to a corner of the Neuman brothers' barn across from their store, where mice living in the bales of hay would often chew pages of the books and had to be chased away.

COMMUNITY DIAL EXCHANGE, 1929. Part of the Pacific Telephone and Telegraph Company, this switchboard was located at the current intersection of Cañada (right) and Woodside Roads, prior to the grade change in the 1940s. The building was later used by the local newspaper, the *Country Almanac*, and currently houses an interior design studio.

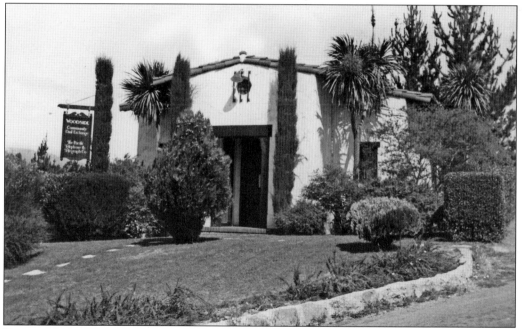

TELEPHONE EXCHANGE. Early telephone service used names as prefixes, followed by four numbers. Woodside's prefix was ULmar, which later became 851. Even today, some of Woodside's more established residents continue to give out their phone numbers using only the last four digits. Similarly, mailing addresses at the time were arranged by route numbers, not road names.

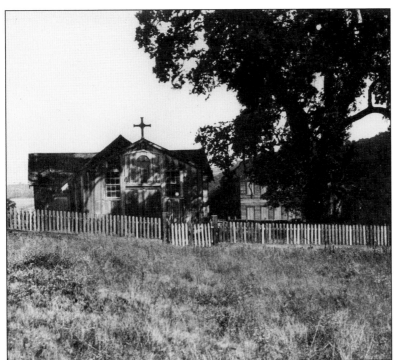

**St. Denis Church.** Dennis Martin came to Searsville in 1845 and soon purchased a large area of land nearby. Martin built a sawmill on San Francisquito Creek. He provided the community with a schoolhouse, which later became the only church between San Francisco and Santa Clara. Catholic bishop Joseph Alemany dedicated it as St. Denis Church in 1853 in honor of its benefactor.

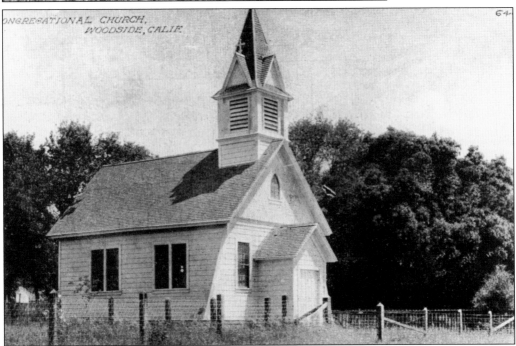

**Congregational Church, 1908.** The small chapel, built in three months in 1893 at a cost of $1,200, has a capacity of 100 people. Built by John Walker with volunteer labor, its first minister was Rev. L.D. Rathbone. It featured a pump organ played by Helen Hubner, a music teacher at the elementary school who was known for rapping students' knuckles with a blackboard pointer when they made a mistake.

**Woodside Village Church.** In 1932, the chapel was renamed Woodside Village Church. Addie Tripp formed the Guild of Church Women in 1936 to provide flowers for the altar, and she organized the semiannual rummage sale in 1937. The first sale netted $66.29, which was used to repair the roof and organ. When a larger sanctuary was built in 1961, the chapel was moved 100 feet east to its current location across from the elementary school. The chapel is still a popular location for weddings and small services.

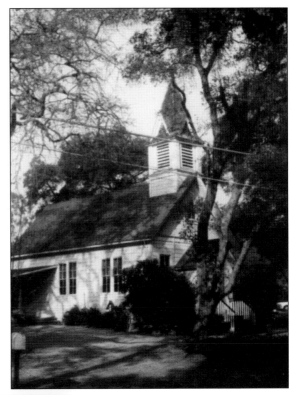

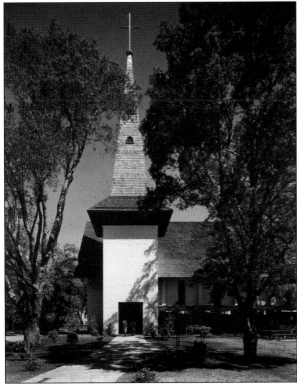

**New Sanctuary, Woodside Village Church.** Martin Wunderlich, Bob Mullen, and Rev. J.H. Snavely led the effort for the building project, completed in 1961, which included Sunday school rooms. The architect was Don Emmons, of the Bay Area firm Wurster, Bernardi & Emmons. The faceted glass windows were designed by San Francisco artist Marc Adams and made by Loire Imports of France. Jim and Dolores Degnan were the first couple married in the new sanctuary. (Courtesy Bob Mullen.)

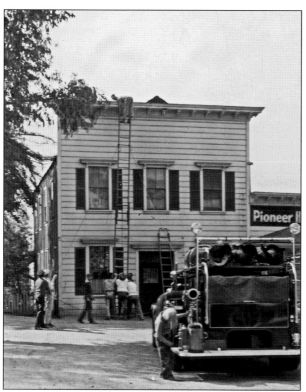

**PIONEER BUILDING FIRE DRILL, 1934.** The Woodside Fire Department used its truck and ladder in an exercise for putting out a roof fire. Aldo Comonoli purchased this building in 1941 and rebuilt it as a hotel, retaining the original façade. In 1946, he opened a large restaurant and bar there. Today, this building houses the Pioneer Saloon and Wells Fargo Bank and has office space on the second floor.

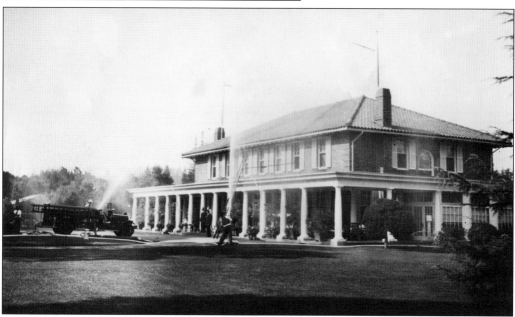

**WHITTELL HOUSE FIRE DRILL, 1932.** George Whittell Jr. hosted a party for San Francisco fire chiefs at his estate near Kings Mountain Road. He asked Woodside fire chief John Volpiano to bring fire trucks, with ladders raised and water hoses at full blast, so guests would have to climb the ladders to enter the house. Volpiano initially refused but later showed up with one fire truck, spraying a curtain of water over the house.

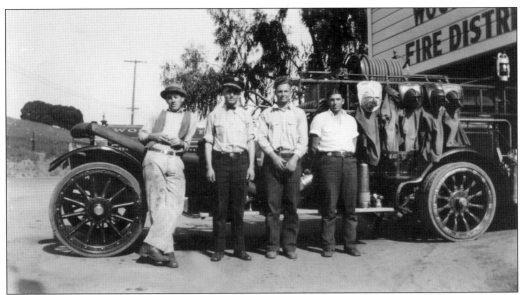

FIRST FIRE HOUSE, 1915. The crew members pictured here are, from left to right, Vern Kelly (who owned the Peanut Farm bar), chief John Volpiano, Poots O'Neill, and Bob Nehmens, whose son Bill also became a fireman. The building later housed a dry cleaners, a bakery, an ice cream parlor, and is now a restaurant named Station One in homage to Woodside's first fire station. The original siren tower is still on the roof.

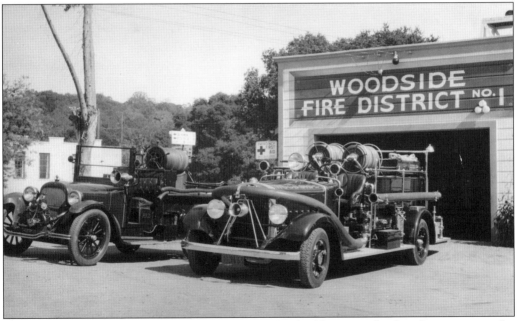

WOODSIDE FIRE DISTRICT NO. 1, LATE 1920s. This building was the first fire station in the Woodside Fire District. There were two fire trucks in Woodside and one at the Portola Valley station. A later station was added in Emerald Hills as part of the Woodside–Portola Valley Fire District. Originally there was one chief and two paid firefighters; the rest were volunteers, who responded upon hearing the siren's wail. The number of siren blasts indicated the part of town in which the fire was located.

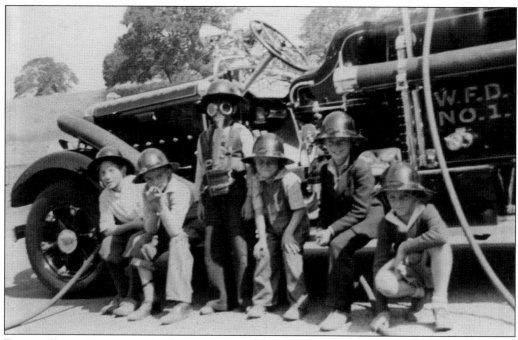

**FUTURE FIREFIGHTERS, 1920s.** Once a year, children from the elementary school were invited to the fire station to experience a real fire drill, including pulling hoses and helping load the ladders on the fire truck. This group includes fourth-grader Lee Rolston (second from left). This truck was affectionately called "Old Mack." The fire truck had wooden ladders and a 750-gallon water tank that could be connected to a fire hydrant for filling. (Courtesy Audiffred family.)

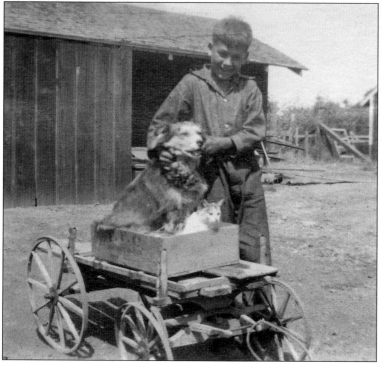

**JACQUES AUDIFFRED, FUTURE FIREFIGHTER, WITH CREW, C. 1927.** From an early age, Audiffred aspired to become a firefighter. He later joined the Woodside Fire District as a volunteer, a post he held until the mid-1980s. Jacques' crew, pictured here, included his dog Laddie and Cat, both sitting in his homemade fire engine. After retiring, Jacques became the official historian of the Woodside Fire Protection District. (Courtesy Audiffred family.)

**JOHN VOLPIANO AND ANDREW LOUSHIN, 1931.** Volpiano (on the left) was chief of Woodside Fire Station No. 1. He served the community for 45 years, and his collection of local photographs forms part of the Woodside Archives. Loushin was Volpiano's brother-in-law. In 1949, the Woodside Fire District became the Woodside Fire Protection District.

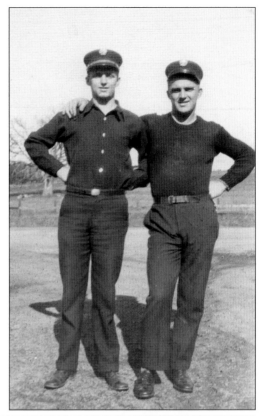

**FIRST FOUR FIRE CAPTAINS, EARLY 1980S.** The captains are, from left to right, Arthur Kitto, Stan Larsen, John Volpiano, and Richard Figone, who gathered at a picnic at Huddart Park for firefighters and their families. Firefighters helped Mark Campbell organize the Woodside Fire Protection District's Citizens Emergency Response and Preparedness Program (CERPP) in 1997; volunteer Gaylynne Mann currently leads CERPP.

**EARLY INDEPENDENCE HALL.** Independence Hall was built in 1884, west of the elementary school on Woodside Road, as a venue for social and political affairs. During the 1920s, it became a place for dances and parties but was closed during Prohibition because of rowdiness.

**FRED MIGHALL.** Mighall is shown here on the steps he built at Independence Hall after it was moved the first time to nearby Albion Avenue in 1944. Mighall and other community leaders, including Fred Eilermen and John Volpiano, persuaded the Boy Scouts to sponsor the renovation of the hall for youth activities and community events.

**INDEPENDENCE HALL, ALBION AVENUE, 1960s.** Henry Koop purchased Independence Hall in 1919 for use as an "amusement place." In the 1940s, money was raised to move and renovate the run-down building. It was renamed Scout Hall and used for community activities and as a meeting place for Boy and Girl Scout troops.

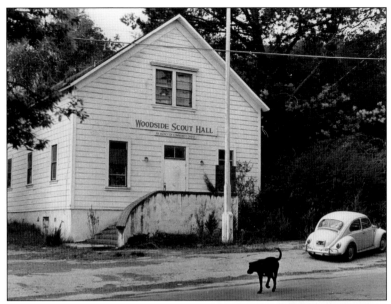

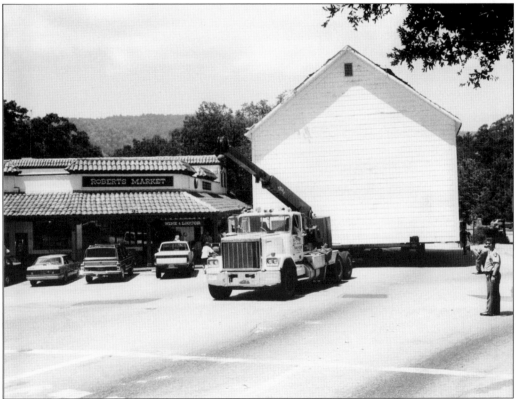

**MOVING INDEPENDENCE HALL, 1991.** Scout Hall closed in 1972 and the building was again abandoned. In 1978, it was moved for the second time, to the elementary school grounds, where it was used for community meetings and eventually placed on the National Register of Historic Places. The building's third move occurred in 1991, when it was relocated next to the new Woodside Town Hall on Woodside Road and rededicated to serve as the town's meeting hall.

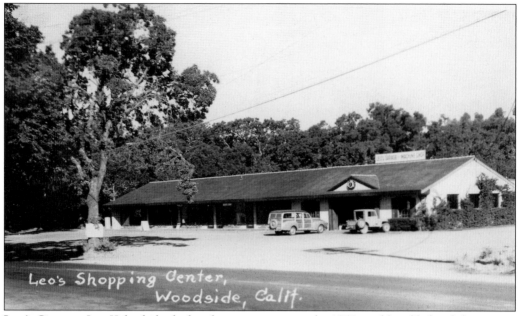

Leo's Shopping Center,
Woodside, Calif.

**LEO'S GARAGE.** Leo Kuboski built this shopping center in the 1950s and lived behind the garage, which had risqué photographs on the walls, according to some residents. His wife was often seen running through the greasy shop in her pink chenille bathrobe with curlers in her hair, preparing herself to look pretty for her husband in the evening. Current owner George Roberts purchased the center from Kuboski in 1967.

**TOWN CENTER.** In addition to Leo's Garage, the first businesses here included the Peterson Fountain, Brown Jug Liquors, a barbershop, the library, Loften Insurance, and Demma's Grocery. Phil Demma, school principal Hal Smullen, pianist Hal Sanford, and bass singer William Wilke formed a barbershop quartet. Today, the center includes Buck's Restaurant, Roberts Hardware, Woodside Tennis Shop, Woodside Art Gallery, Cañada Cleaners, Images Salon, Woodside Bakery & Café, and Emily Joubert gift shop.

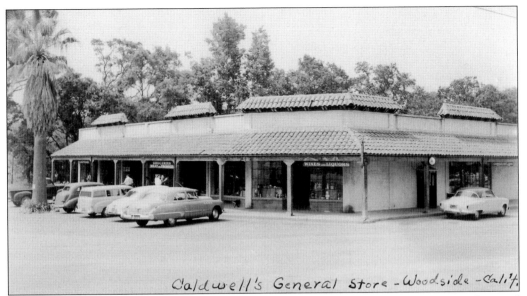

*Caldwell's General Store - Woodside - Calif.*

**CALDWELL'S GENERAL STORE.** Emott Caldwell bought the store business in 1950 and named it Caldwell's General Store, although the Neuman family retained ownership of the property. Caldwell's originally included a hardware section, along with a liquor department and a meat market. During the holidays, Christmas trees were sold on the walkway outside. Caldwell's son Jim, an architect and artist, lives in town with his family.

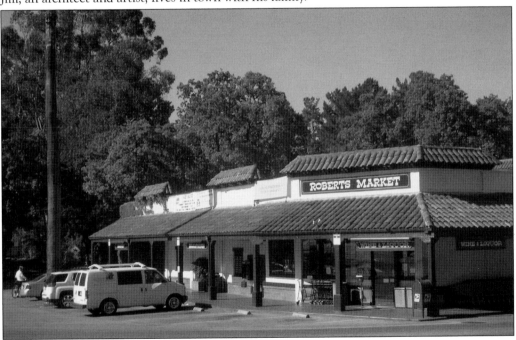

**ROBERTS MARKET.** Resident George Roberts, whose father, William Roberts Jr., was a second-generation butcher in San Francisco, bought the store business from Emott Caldwell in 1960. Roberts purchased the property from the Neuman family in 1975. Celebrating its 50th anniversary in 2010, the market serves as a gathering place at the crossroads of town and has become the center of the community.

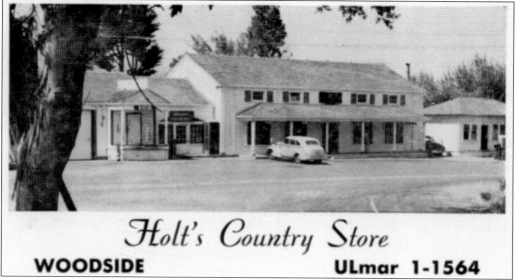

# Holt's Country Store

**WOODSIDE**                                    **ULmar 1-1564**

**HOLT'S COUNTRY STORE.** Operated by Clarence "Ancie" and Louisa "Babe" Holt, Holt's was a full-service grocery with home delivery. Hank Gragg, the butcher, later worked at Roberts Market. Harold Zwierlein worked at Holt's as a teenager, washing out wine jugs. It was cold in the basement, so he once decided to "clean out" the bottles by drinking the dregs. Soon he was throwing the bottles against the concrete foundation and had to be driven home.

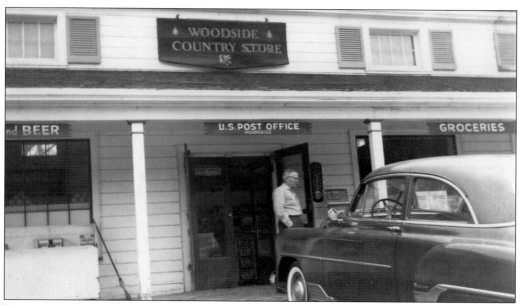

**HOLT'S STORE WITH POST OFFICE.** In 1943, Tony Zaepffel sold his ice business to the Holts, who incorporated it into their grocery store. The Holts delivered ice as well as groceries. In 1953, they opened a US post office with Babe Holt as the agent. The Holts credited their success to equal treatment of both rich and poor customers, and in 20 years of business they received only three bad checks. After the Holts sold the business in 1963, the store became a dress shop and is now a real estate office.

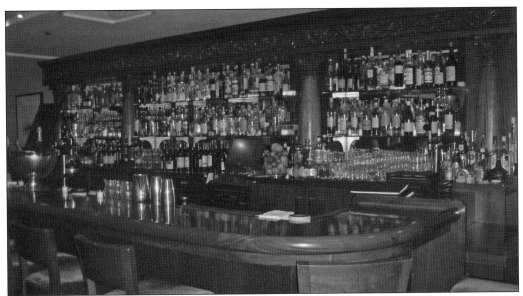

**VILLAGE PUB, 2011.** This restaurant was owned and operated by Jack Schutz and Ralph Oswald from 1958 until the mid-1990s. It was the fancy place for dinner in town, requiring jackets for gentlemen, and was also popular as a destination bar. Next-door was the Pub Pantry, a delicatessen that had the Pub's famous soups and entrées available for take-out. A new building in the same location houses the new Village Pub, including the salvaged, carved wooden bar (pictured) from the former Pub.

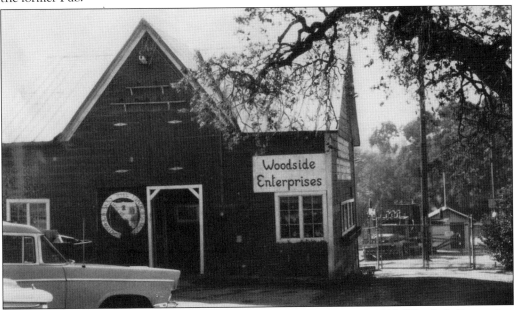

**WOODSIDE ENTERPRISES, 1960.** Built as a barn by Capt. Peter Hansen in 1880, Woodside Enterprises was bought by J.V. Neuman in 1910 in conjunction with his second grocery store. In 1930, Neuman sold it to Botchio Arata as part of his feed and fuel store. Subsequently, the Mathisen family bought and leased it as a gift shop until a storm knocked it down in the late 1970s. Operated by Barbara Donald, Jean Law, Betty Wynn Holbrook, and Syd Lucas, the shop featured eclectic merchandise, antiques, greeting cards, and paintings by local artists.

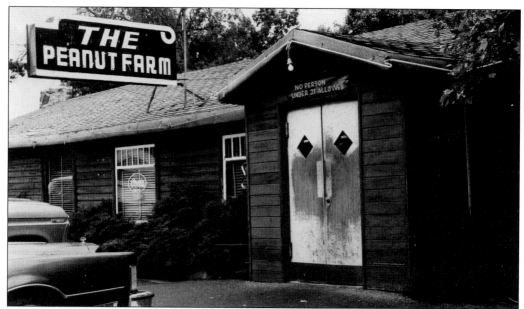

**The Peanut Farm.** Originally a tea garden in the 1920s, the Peanut Farm bar was located on Cañada Road at the entrance to the Glens subdivision and was one of three "watering holes" in town until 1989. The old wooden-plank floor, covered in peanut shells thrown there by drinking patrons, bounced when people danced. Fights often broke out between unarmed cowboys, but there was no need to call the sheriff, since one of them was usually there. The Peanut Farm has been converted to a private residence.

**Peanut Farm Gang.** All strata of Woodside society mixed at this popular bar. Local farriers met once a year for a steak dinner served by owner Andy Stagnaro. He also hosted a free dinner on St. Patrick's Day, a tradition begun by Vic Balloccio and Vern Kelly, former owners from the 1940s to the late 1960s. Patrons tied their horses at the hitching post while having a beer and a sandwich. Murray Foster would often shoot off his cannon in the parking lot, and at Christmas, the community gathered around a bonfire there.

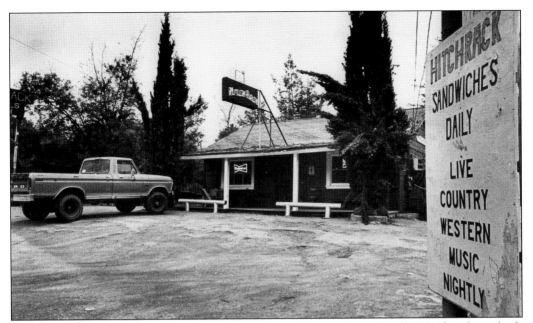

**HITCHRACK, 1983.** Located on Cañada Road, north of Jefferson Avenue, the Hitchrack was built in the 1920s as a western bar. A favorite motorcycle hangout, it was owned by Buck and Gertie Gray, purchased by Harold Zwierlein and Butch Coggins in 1974, and sold to Andy Stagnaro in 1976. On Monday nights, patrons were served free spaghetti with their drinks. A large oak tree outside had cowboy boots nailed to its trunk. The Hitchrack closed in 1986.

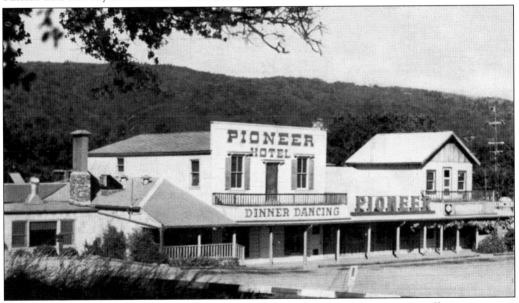

**PIONEER HOTEL SALOON.** This saloon, featuring live music and dancing, is still in operation. Aldo Comonoli bought the establishment in 1941 from Harmon Wilson, who had purchased it from Walter Jelich. In 1942, Harold Zwierlein rode his horse through the swinging doors into the saloon on a dare, which bartender Bud Cheney, being a horseman himself, did not mind. Aldo's wife, Bodie Comonoli, renovated the structure in 1958, transforming it into an elegant dinner house and cocktail lounge.

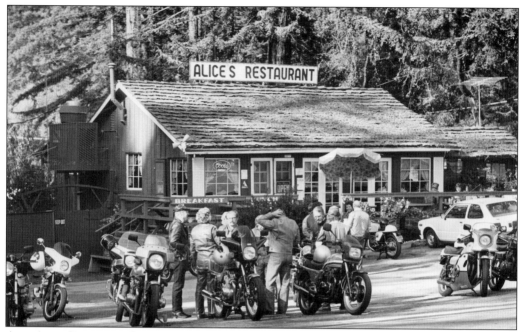

ALICE'S AT SKYLONDA CORNERS, 1982. Built as a general store in the early 1900s to serve the lumber industry, this building was converted to a restaurant in the 1950s. Alice Taylor bought it in the 1960s, renaming it after herself and the Arlo Guthrie song "Alice's Restaurant." Other establishments at this intersection, known as Four Corners, include two gas stations, another restaurant, a grocery store, and a real estate office. It remains a favorite stopping place for travelers en route to the coast.

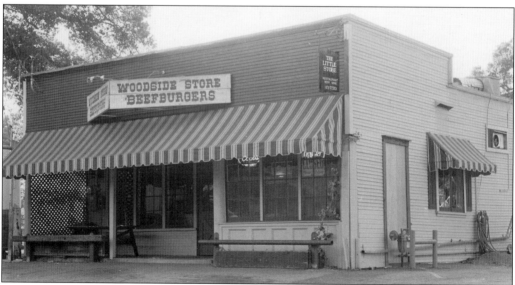

THE LITTLE STORE. This popular restaurant on Woodside Road began in 1907 as a grocery store. In the 1940s, after the change in grade along Woodside Road forced him out, Fred Heiser moved his grocery business here. It included a gas station and soda fountain, where kids could purchase long cinnamon sticks. Marcel and Kay Mouney purchased the property in 1973 and live behind the restaurant.

# Six

# ESTATES AND OENOPHILES

By the 1880s, the bucolic countryside and ideal climate of Woodside had begun to attract the gentry of San Francisco, who saw the town as a perfect place to build their country estates. Coffee magnate James Folger built an architectural masterpiece in 1905 on Hazelwood Farm. Mortimer and Bella Fleishhacker built an estate named Green Gables in 1911. Copper baron Daniel Jackling built a Spanish Colonial Revival mansion near Mountain Home Road in 1926. Spice merchant August Schilling owned a compound, which included a greenhouse, at Old La Honda and Portola Roads, and ship chandler Charles Josselyn built his Vinegrove Estate near Kings Mountain Road. Eccentric George Whittell Jr. spent his family fortune on fast cars, exotic animals, antiques, and beautiful women. The Rosekrans family built Runnymede Estate, featuring a large English Tudor stable.

William and Agnes Bourn, who made their fortune from the Empire Gold Mine in Grass Valley, hired architect Willis Polk in 1915 to build a Georgian Revival mansion on their Filoli estate, located north of Woodside.

Around 1880, after the vast stands of redwoods had been depleted, entrepreneurs turned to agricultural businesses, including vineyards. The first person to plant a vineyard, just north of Woodside, was Hungarian Agoston Haraszthy, often referred to as the "Father of Viticulture in California." Emmett H. Rixford established La Questa Vineyards in 1883. Rixford's cabernets were of such quality that they were exported to Europe. Dr. Robert Tripp also had a small vineyard and exhibited his wine at the 1893 San Mateo County Fair. In 1894, John A. Hooper purchased the Charles Brown estate, where he planted a vineyard.

Many of the grand estates have been preserved, and viticulture continues to be a viable form of agriculture in the Woodside area.

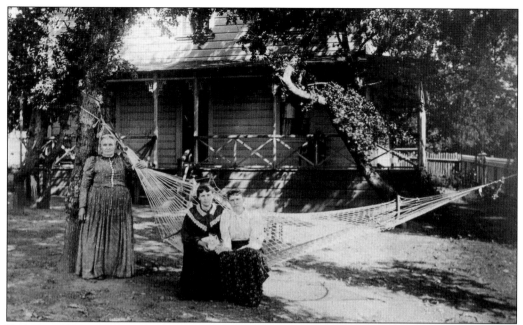

**Bottger House, 1868.** Catherine Bottger (standing), with daughters Edith (on the left) and Lucy, lived in the house pictured here until 1918. Lucy married Joseph Hallett and they lived on Albion Avenue, raising seven children. Three of the Hallett children spent their entire lives in Woodside—Ethel ("Squack"), who worked at Holt's Grocery; Alvin ("Tick"), who was assistant chief of Woodside Fire District; and Carroll ("Dutch"), a local electrician.

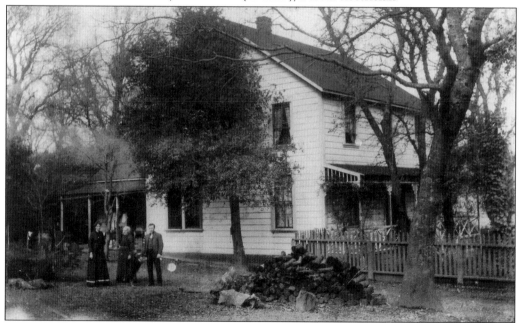

**Bottger House, 1870s.** Located near Greer Road (formerly Huddart Farm Road) and Kings Mountain Road, this was the home of tollhouse operator Henry Bottger and his family. In 1918 Herman and Ella Poetsch bought the house and rebuilt it in 1934 after it was destroyed by fire. Their descendents, the Wagner Krenz family, continue to gather there for Sunday dinners.

**MIGHALL-VELIQUETTE-RICE HOUSE.** Fred Mighall built this house in 1900 after he married Belle McArthur, whose father, Hugh McArthur, owned a sawmill. The house is occupied by members of the original family and is currently being restored by Hugh and Elizabeth McArthur's great-granddaughter Judy Rice and her family.

**NEUMAN FAMILY HOME.** This house, also used as a hotel, was located near Bear Gulch and Woodside Roads and was part of the area known as Neuman's Grove. The 1893 *Redwood City Democrat* called it "one of the best places for a week's sojourn in the country." Neuman had an orchard and greenhouses here, which were used to raise fruits and vegetables that he sold at the store.

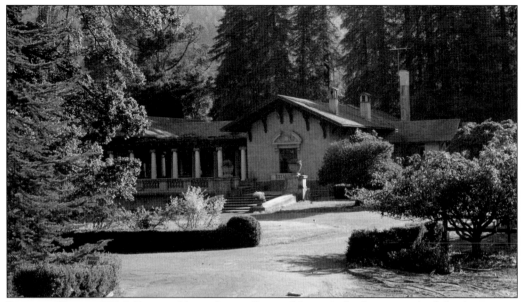

**Josselyn House, 1906.** Designed by architect George Howard, this house was built by ship owner William Greenwood as a hunting lodge. It was built on the rubble of a house destroyed in the 1906 earthquake. The estate, managed by Joseph Hallett, was given to Greenwood's only daughter, who married Charles Josselyn. Located on Union Creek, near the Kings Mountain Road bridge, the house remains a private residence. The estate sold in 2011 for $15.4 million.

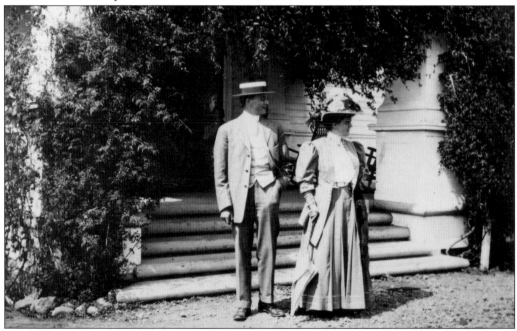

**Edgar Preston and Wife.** The Prestons are shown here in front of their impressive mansion on Preston Road, located off Old La Honda Road, near Portola Road. This San Francisco attorney built his home here in 1887, constructing a vineyard, along with a three-story winery with a 175,000-gallon capacity. Spice merchant August Schilling purchased the estate in 1912 and maintained it as a family summer home. Only a few remnants of the stone winery remain.

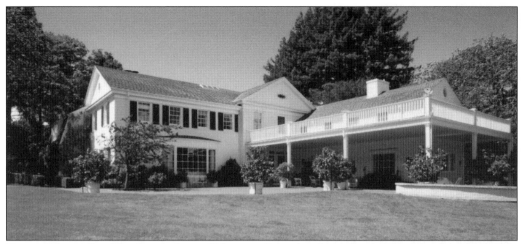

**FLOOD HOUSE.** Jim Flood, grandson of Virginia City silver king James Clair Flood, and his wife, Betty, purchased 90 acres near what is now Huddart Park in 1941 and built their home. Here, they raised four children—James, Judy, Elizabeth, and John. Jim was a director of Wells Fargo Bank and managed the Flood Building in San Francisco. Betty, who was an accomplished equestrian and watercolorist, passed away in 2011 at age 94. (Courtesy Elizabeth Stevenson.)

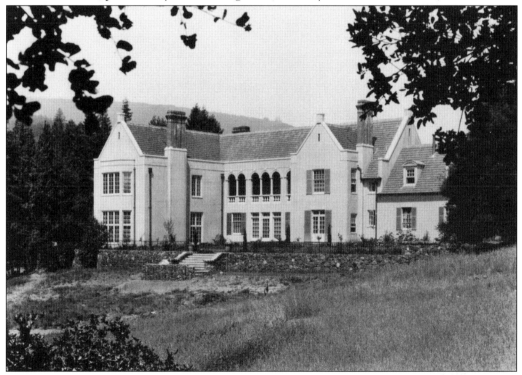

**MOUNTAIN MEADOW ESTATE.** Sam Eastman was vice president of the Spring Valley Water Company. He commissioned architect (and fellow employee) Gardner Dailey to design this "modest" 8,000-square-foot home, based on the plan of the Filoli mansion, in 1926. San Francisco attorney Herman Phleger and his wife, Mary Elena, purchased the property in 1935, and it was sold to a Silicon Valley entrepreneur in 1991. Today, 1,232 acres of the estate are part of the Golden Gate National Recreation Area.

**Duncan Property.** William and Myra (Josselyn) Duncan owned this property located at the corner of Kings Mountain and Woodside Roads, which was part of the original Cañada de Raymundo land grant. Horse-riding classes for the Junior Riders program were first held here at Duncan's ring. The buildings were demolished in 1998.

**Water Tower, Duncan Property.** Also called a tank house, this typical wooden tower provided water for early residents' needs. Water was collected in a tank on top and fed by gravity through pipes to the house and barns. Later, water was supplied from drilled wells until a public water system was installed throughout the town.

**LOG CABIN.** This cabin, built by Norwegian hunters in 1904 as a lodge, survived the 1906 earthquake. It was later converted to a private residence. Located near Albion Avenue, it belonged to the Ross family and was sold in 2010 to the Werbe family, who lovingly restored it as a guest cottage.

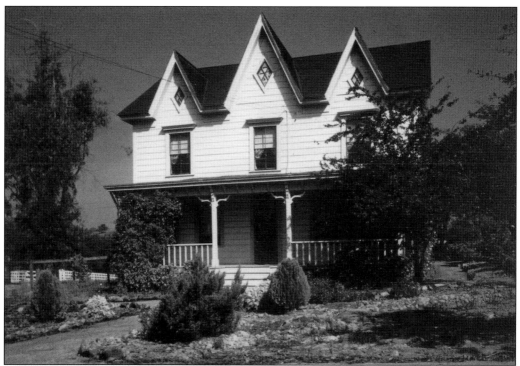

**SHINE HOUSE, 1991.** In 1882, Irish immigrants Michael and Bridget Byrne built this Victorian Gothic house on Cañada Road from a mail-order plan. Their daughter-in-law's brother, Judge Albert T. Shine, inherited the house in 1939. The interior contained 19th-century furnishings until the house was sold and renovated in 1998. This house is listed with the California State Office of Historic Preservation and is a private residence.

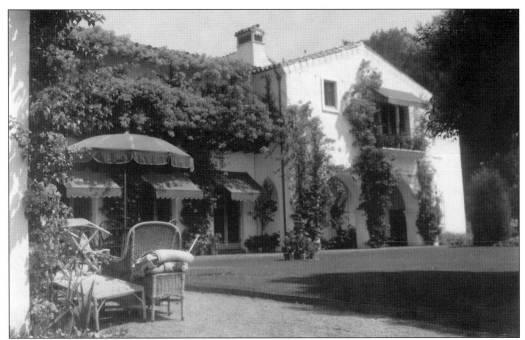

**JACKLING ESTATE.** In 1921, copper baron Daniel Jackling bought a 140-acre estate from W.C. Talbot for $225,000, which was then the most money ever paid for a home in San Mateo County. Jackling commissioned architect George Washington Smith to design a new house in the Mission Revival style (pictured above and below). The 12,000-square-foot house had thick stucco walls, decorative handmade Tunisian and Spanish tiles, and tile roofs. Jackling invented an improved method of extracting copper from the ore, and many elements of the house, including gutters and downspouts, were made of copper.

**JACKLING HOUSE.** This photograph shows the porte cochere, a covered entrance that provided protection from the weather for carriages passing through. Many large festive social gatherings took place here, and at Thanksgiving, Jackling gave away his homegrown turkeys. The estate was sold to William Luce in 1960. Jackling descendant Virginia Gill Andersen still lives in the area with her family. Apple co-founder Steve Jobs purchased the estate in 1984 and demolished the house in 2011.

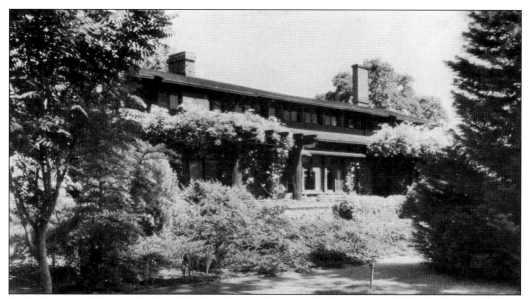

**ELISE DREXLER HOUSE.** Designed by Bay Area architect Julia Morgan in 1913, this house was later purchased by Dennis and Suzie King, who opened their home and property to residents every spring to view the vast displays of flowers. The property was a typical California landscape, with large native oaks on rolling terrain. The house was purchased by Oracle CEO Larry Ellison in 1996 and was later dismantled.

**JAMES FAGAN HOUSE, 1920.** This house, located near Whiskey Hill Road, was designed by Bay Area architect Bernard Maybeck. The low-scale stucco and beam structure with tall windows and wide overhanging eaves exemplifies the concept of living in the natural landscape, an idea that is central to the current ethic and planning principles of the town. Portions of the house have been restored.

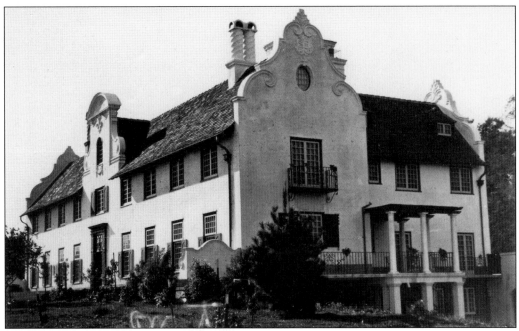

**MEIN HOUSE.** Scottish descendant William Wallace Mein Sr., influenced by his work in South Africa as a mining engineer, built this Cape Dutch Colonial house in 1928. Designed by English architect Sir Herbert Baker, it was constructed of reinforced concrete with a slate roof. The U-shaped house, which surrounds a large courtyard, continues to be the site of many social gatherings.

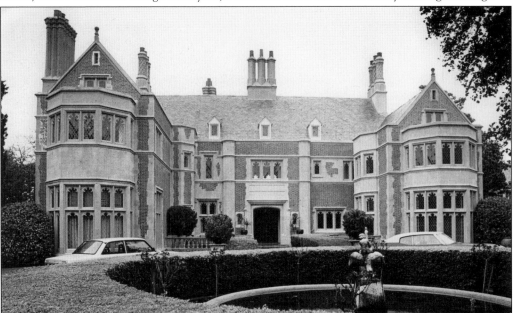

**BUCK ESTATE.** Designed by architect Albert Farr in 1934, this 40-room English Gothic estate, located on Northgate Drive, was built by Walter E. Buck. Between 1982 and 1985, an enterprising group of Roman Catholic Brigittine monks transformed the house into a monastery, making and selling fudge between prayer sessions to help support themselves. The monks were allowed to live here rent-free in exchange for maintenance work. It is again a private residence today.

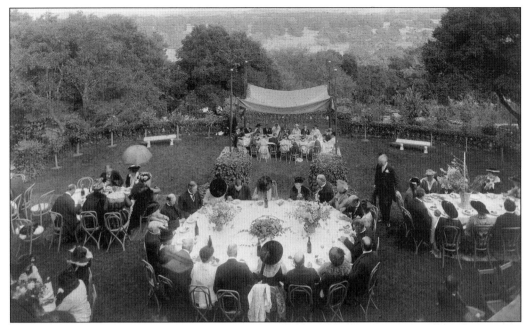

**WEDDING AT FOLGER ESTATE.** San Francisco coffee magnate scion James A. Folger II moved to Woodside in 1902. In 1905, he commissioned architect Arthur Brown Jr. to design an Edwardian-style mansion on what was called Hazelwood Estate, the site of many social affairs. The property had sulfur springs, and Folger intended to build a resort here. Nolan Bushnell, founder of Atari, bought the 13-acre estate in 1976 for $500,000; he also held lavish parties at Hazelwood until he sold it in 1998.

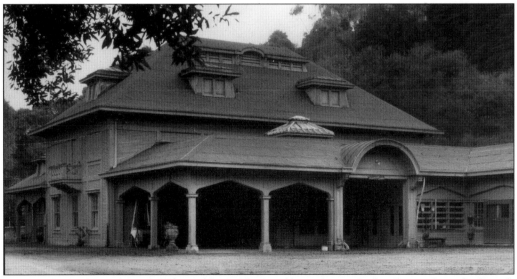

**FOLGER ESTATE STABLE, 1905.** The stable was designed by architect Arthur Brown Jr. in the French Baroque style. An energetic group of citizens hired architect Adolph Rosekrans to design the restoration, which was completed in 2010, and it was placed on the National Register of Historic Places. The stable is now part of Wunderlich Park and maintained by San Mateo County. An interesting feature is a moss-covered rock wall behind the stable that was built in the 1870s by Chinese laborers.

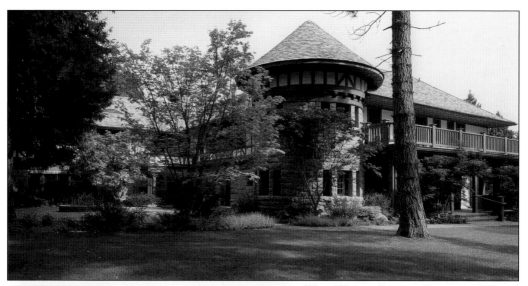

**WHY WORRY ESTATE.** Between 1898 and 1900, Swedish immigrant Capt. William Matson, of Matson Navigation Company, built a 38-room Tudor-style house on 70 acres along Woodside Road near Bear Gulch Creek. The estate was given to his only child, Lurline, an avid horsewoman, who named it Why Worry Farm in 1925. Here, she bred and trained American saddlebred and harness horses, as well as hackney ponies. Lurline married William Roth and they purchased and moved to the Filoli estate in 1936.

**OCTAGONAL BARN.** Part of the original Matson estate, this architecturally unique 10-stall pony barn was built in 1925 around a small training ring. The surrounding atrium has hand-painted murals depicting hunt and riding scenes (see detail) on pine paneling. The faded murals and barn were restored in the 1980s, and the barn is still in use.

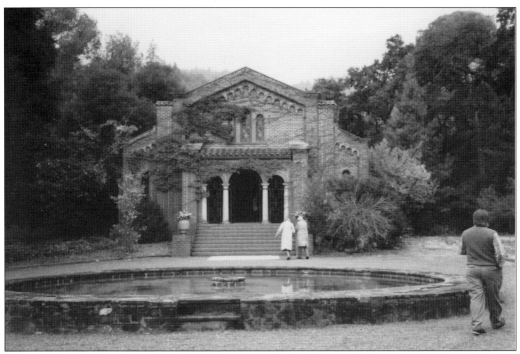

**THEATER AT WHITTELL ESTATE.** This private theater near Kings Mountain Road was part of a 50-acre estate belonging to socialite George Whittell Jr. and his wife, Elia Pascal. Connected to a carriage house via an underground tunnel, it was used during Prohibition so arriving guests could proceed unseen to large parties where liquor was served. The estate's current owner, Apple entrepreneur Mike Markkula, has restored the theater. (Courtesy Bob Moll.)

**ELIA WHITTELL AND "BABY," 1930S.** Elia is pictured here in the study with her pet cheetah, Baby, which her eccentric husband, George, used to drive around town in his Duesenberg convertible. Local children remember hearing lions roar when walking past the property. Whittell's menagerie included a giraffe, an elephant, a lion, and other exotic animals. With no heirs, most of Whittell's fortune was distributed to various animal welfare organizations following his death in 1969. (Courtesy Bob Moll; photograph by Berton Crandall.)

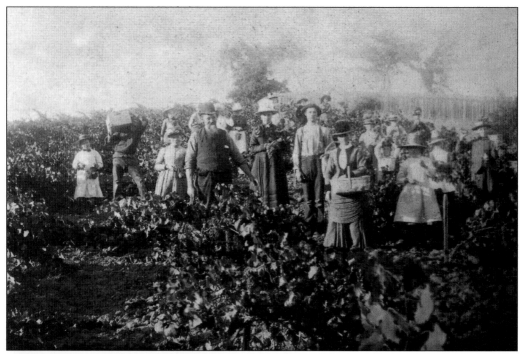

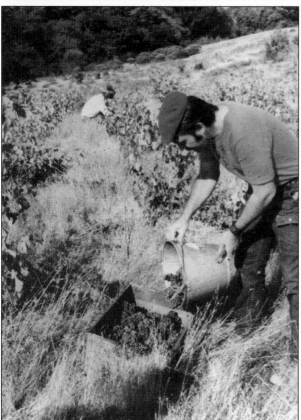

**WINKLER VINEYARD, 1880S.**
The Winkler home and vineyard are on Fox Hollow Road. The bearded man in the photograph is village blacksmith John K.G. Winkler. Woodside was a major wine-producing region from the 1880s through the early 1900s. After the forests had been cut, the fertile bottomlands and hillsides were converted to agricultural use, including vineyards. Viticulture continues today, with many backyard vineyards supplying grapes to local wineries.

**HOOPER VINEYARD.** Pickers harvest cabernet sauvignon and zinfandel grapes at the Hooper Vineyard, near Mountain Home Road. Note that the vines are not trellised, as is now common. Planted in 1894, today only about five acres remain of the original 40-acre vineyard. Vestiges of the two-story stone winery can still be seen from the horse trail below Vintage Court.

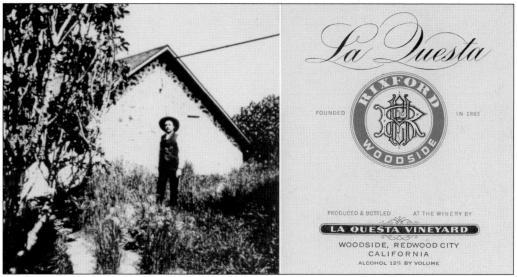

**LA QUESTA WINERY.** Emmett Hawkins Rixford, a San Francisco attorney, established this winery in 1883 with 7,000 vines imported from France. In 1902, Rixford hired Swiss stonemason Charles Rose to build the winery using stones uncovered while planting the vineyard. Although damaged in the 1906 earthquake, Rose rebuilt the winery, which was later converted to a private residence. Now less than an acre, the vineyard continues to produce a small amount of the coveted La Questa Cabernet Sauvignon, bottled by Woodside Vineyards. (Courtesy Bob Mullen.)

**BLESSING OF THE GRAPES, 1964.** Susie Eisenhut Bors (at right) watches Woodside Village Church pastor Jay Snavely (holding the cross) and associate pastor Pat McConnell perform the annual blessing of the grapes at Woodside Vineyards, established by Bob Mullen on Kings Mountain Road. Part of the harvest was made into communion wine for the church. (Courtesy Bob Mullen.)

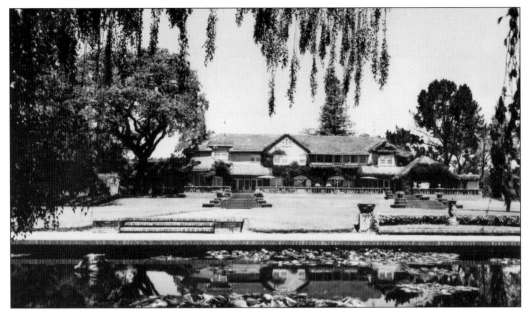

**GREEN GABLES, 1912.** Charles Greene, of the architectural firm Greene & Greene, designed this summer home for San Franciscans Mortimer and Bella Fleishhacker. The English-style country house has gunite walls and the cedar shingle roof is steamed and shaped to resemble thatch. Greene later designed and built the game room as an addition to the house, which included carved wood paneling, furniture, tile, and a stucco frieze.

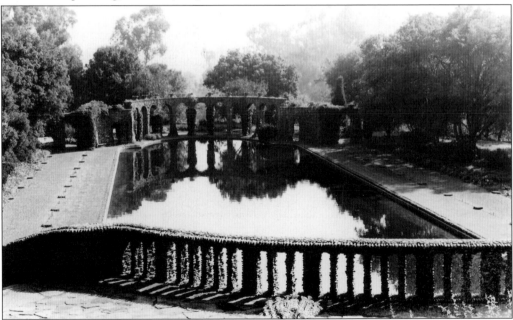

**FLEISHHACKER ROMAN POOL, 1927.** This pool was designed by architect Charles Greene to enhance the view from the upper terrace and emulate Italian reflecting pools. Greene also designed the landscaping of stone walkways, ceramic planters, trees, and a large expanse of lawn for entertaining. Many grand social and fundraising events have been held there. The Fleishhacker family has ceded the development rights of this property to The Garden Conservancy.

**MATHISEN FARM HOUSE.** Capt. Peter Hanson's widow, Anna, married Peter Mathisen, a coachman for J.A. Hooper. According to legend, the house was completed the day before the 1906 earthquake. Mathisen's son Arthur and Arthur's wife, Dora, raised their five children—two sets of twin girls and a son—in the house. The family lived in the house until 1991. A barn and a bunkhouse for farm workers were on the property.

**WOODSIDE COMMUNITY MUSEUM, 2011.** Slated for demolition, the Mathisen house was saved and renovated in 2003 with private funding organized by the Woodside History Committee, led by Jeanne Dickey. It now houses the Museum and other offices. The committee members pictured here from left to right are Richard Tagg, Dolores Degnan, Lisha Mainz, Bob Mullen, Gretchen Tenenbaum, Patty Nance, Delia Ehrlich, Jennifer Werbe, Thalia Lubin, Cutty Smith, and Bill New. (Courtesy Kevin Bryant.)

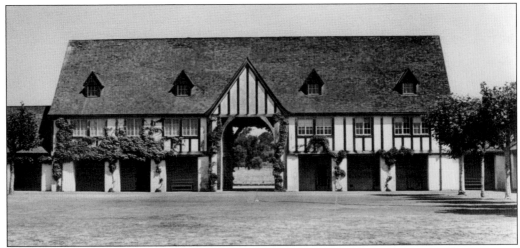

**RUNNYMEDE STABLE.** John Rosekrans and his wife, Alma Spreckels, purchased 53 acres near Cañada Road in 1930. Alma commissioned architects Bakewell & Weihe to design this classic English Tudor stable, completed in 1931. Alma's father, Adolph, was one of the founders of Tanforan Racetrack and a horse breeder whose racehorse, Morvich, won the Kentucky Derby in 1922. The stable and road were named Runnymede after Adolph's favorite stallion.

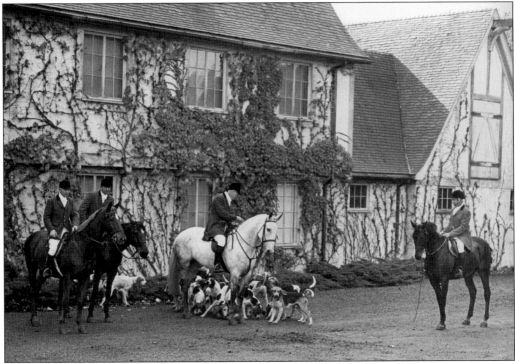

**HUNT AT RUNNYMEDE, C. 1960.** In the 1930s, Runnymede was famous as a hunter-and-jumper stable, housing 50 horses. Grooms and trainers lived in the quarters above the stalls. Alma Rosekrans was a champion horsewoman. She helped to shape the landscape and doubled the size of the estate, only to lose part of it during the construction of I-280. Today, the estate includes more than 150 sculptures from many famous American and international artists. Alma's grandson, Adolph, has an extensive farm equipment collection on the property.

# Seven

# NOT A ONE-HORSE TOWN

Woodside residents have always had a love affair with horses. As large estates were established, the role of the horse evolved from utility to pleasure and sport. Daniel Jackling built his stables near Mountain Home Road in 1925. James Folger II built the elaborate Folger Stable as part of his Hazelwood Estate. The Tudor Revival stable at Runnymede Farm was built for Alma Spreckels Rosekrans, granddaughter of sugar king Claus Spreckels. The community's passion for horses led to the creation of both a private and a public trail system throughout the town.

The Mounted Patrol of San Mateo County, originally created to watch for enemy submarines off the coast during World War II, evolved to help with search and rescue operations after the war. The patrol now hosts the July 4th Junior Rodeo and San Mateo County Horsemen's Association's Western Riding Clinic. Other equestrian groups in the area include the Los Altos Hounds, the Junior Riders children's program, and several vaulting groups.

Woodside Vaulters began in 1990, preceded by Sundance Vaulters in the 1970s. Vaulting involves young athletes performing gymnastics atop moving horses. The National Center for Equine Facilitated Therapy (NCEFT), originally at Somers Field along Woodside Road, is now located at Runnymede Road and offers therapy for children and adults with neuromuscular disorders. The Woodside Horse Owners Association (WHOA), formed in 2004, promotes equestrian events. The Woodside Horse Park conducts polo, dressage, carriage driving, and other equestrian sports. The Peninsula Carriage Driving Club hosts an annual Christmas carriage drive through the town that includes the singing of carols. Longtime resident and club member Jeannette Rettig (descendant of both the Winkler and Bradley families) helps to organize the event.

Horses are still a popular means of transportation in Woodside, with riding trails throughout the town and hitching posts at many public locations.

**JOE GREER.** Born in 1897, Joe Greer was a descendant of one of the early pioneer families and was truly a town character. He is shown here with his mule, plowing the field at the family homestead on Kings Mountain Road near Woodside Road. Greer would show up at the town center with manure still on his boots, and many children were frightened of his gruff demeanor.

**JACKLING STABLES.** These stables were originally part of the Jackling estate. This photograph, taken on December 6, 1941, shows Roy (on the horse) and Gene Schweninger, who lived in the upstairs quarters and worked as trainers for Jackling's horses. The day after this photograph was taken, Pearl Harbor was bombed and the two men quit their jobs to enlist in the Marines. This classic horse facility still stands. (Courtesy Sharon Schweninger Humphreys.)

**LURLINE MATSON ROTH WITH MY JOY, 1920s.** Lurline Matson Roth competed nationally and won many awards for her equestrian skills. Her family purchased the 125-acre Filoli estate, where she lived until 1973, from the William Bourn family. The name "Filoli" was derived from an acronym for "fight, love, live." The estate, including vast gardens, was donated to the National Trust for Historic Preservation in 1975 and is open to the public.

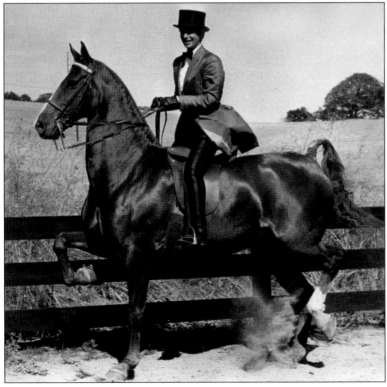

**DELIA FLEISHHACKER EHRLICH, C. 1965.** Delia is shown riding English-style on Country Gal, a prizewinning American three-gaited saddle horse. On a three-gaited horse, the rider wears a top hat, while one wears a bowler hat on a five-gaited horse. The gaits include walk, trot, canter, slow gait, and rack. Delia is a member of the Woodside History Committee and spends her summers in a William Wurster–designed house at the Fleishhacker estate. (Courtesy Delia Ehrlich.)

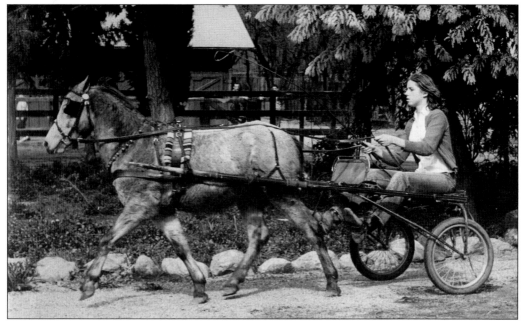

SHARON SCHWENINGER, 1962. The Schweninger family moved from San Mateo to Woodside in 1956 and initially lived at the Little Store. Roy Schweninger was a horse trainer who purchased land from Irishman John Galvins on Fox Hollow Road. This photograph of a cart and Welsh pony was taken at Galvins's property, which he called the Play Pen, so named because it was also intended as a place for children to play. (Courtesy Sharon Schweninger Humphreys.)

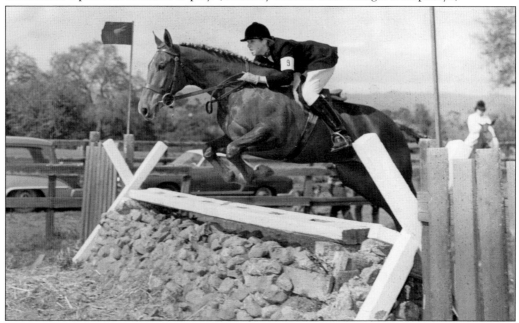

GUERNSEY FIELD, 1962. Roy Schweninger was a horse trainer who leased his land on Fox Hollow Road from Irishman John Galvins. This photograph of a cart and Welsh pony was taken at Galvins' property, which he called the Play Pen, so named because it was also intended as a place for children to play. (Courtesy Sharon Schweninger Humphreys.)

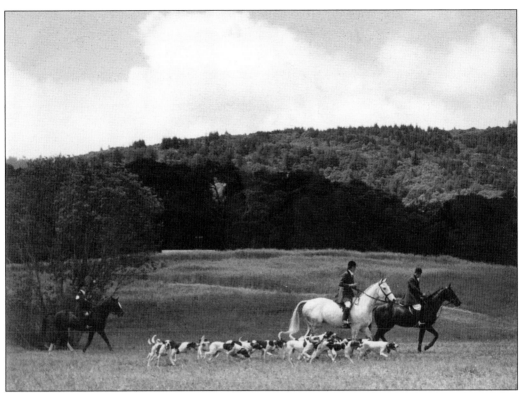

**FOX HUNT, EARLY 1960s.** John Galvins invited the Los Altos Hunt to move the group's foxhound kennels to the Play Pen on Fox Hollow Road in 1956. Walt Disney began filming *Raynard, the Silver Fox* there around 1958 with stars Rosemary Clooney and José Ferrer; however, the film could not be completed because, during the first take, the "trained" silver fox didn't respond to the return whistle and took off for the hills. (Courtesy Sharon Schweninger Humphreys.)

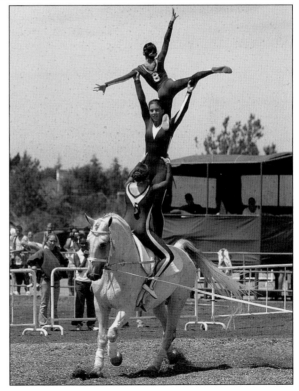

**WOODSIDE VAULTERS, 2000.** In 1990, Linda and Jim Bibbler, along with their daughter Isabel, founded the Woodside Vaulters. The group practices at Sydney and Dick Frankel's property on Josselyn Lane. The vaulters riding Gucci at the national championships are, from top to bottom, Elizabeth Osborn, Jackie Bors, and Briana Olson. The Woodside Vaulters won a bronze medal at the World Equestrian Games in Rome, Italy, in 1998. (Courtesy Susan Bors.)

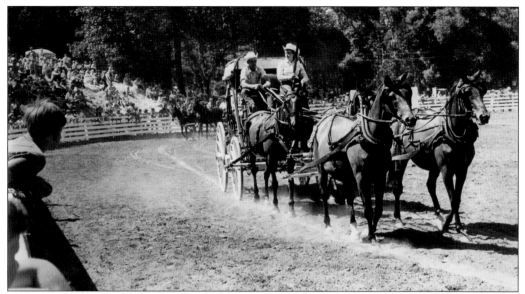

**GRAND ENTRY AT RODEO, 1980s.** Originally held at the Glass Ranch on La Honda Road, the July 4th Junior Rodeo celebrated its 60th anniversary in 2010 at the Mounted Patrol Grounds on Kings Mountain Road. The rodeo is hosted by the Mounted Patrol of San Mateo County, which was founded in 1942 by Rich Delucchi, Bud Dickey, Dale Ryman, Clyde DeBenedetti, and others. It continues as a mostly social club, and women are still not admitted as members.

**MOUNTED PATROL JULY 4TH JUNIOR RODEO, 1977.** The Mounted Patrol purchased land on Kings Mountain Road in 1947 and constructed a clubhouse for its members and facilities to host events. The most famous of these events is the annual July 4th Junior Rodeo, first organized in 1967 by Harold Zwierlein and his brother Ed Zwierlein Jr., both members of the San Mateo County Horsemen's Association. Participants have to be under 18 years old to participate. The kids in this pig scramble are trying to catch a pig while another one escapes! (Courtesy Zwierlein family.)

**JUNIOR RIDERS, 1955.** In 1945, Myra Duncan (wearing hat) began the Junior Riders program at her property near Kings Mountain and Woodside Roads to teach children the joy of riding horses. She is shown here with her daughter-in-law Barbara and grandsons Dennis (in front) and Skip (on their pony Jimmy). Myra and her sister, Marjorie Josselyn, were avid equestrians who helped form the Woodside Trail Club in 1922. The sisters lived in Woodside their entire lives.

**VLADIMIR TEROFF PETOROVO-MILORADOVICH.** Affectionately known as "Milo," Petorovo-Miloradovich was an accomplished horseman who was brought to Woodside in 1929 by Stanley Harris to teach Harris's children to ride. Originally from Russia, Milo saw action in both world wars and the Russian Revolution. In 1947, he joined Myra Duncan and the Junior Riders program to teach the finer points of horseback riding to Woodside children.

**JOHN R. KIELY EQUESTRIAN CENTER.** During the population growth of the 1950s, property on Tripp Road was purchased for a possible second elementary school. Woodside acquired the property in 1976 for the Junior Riders program, which began at Myra Duncan's property (shown in this photograph) and continues today. The facility is shared with the Woodside Pony Club and the Woodside Vaulters program. One of the barns is named after Ursula Eisenhut, who ran the program from 1967 until 2001. (Courtesy Kathy Felix.)

**SHACK RIDERS.** Recreational trail riders from the Menlo Circus Club gathered at an old building near Searsville Lake, called "The Shack," after the area became Jasper Ridge Biological Preserve. In 1975, the Shack Riders moved to a new facility within the Jasper Ridge Biological Preserve. Membership was exclusively male until Rozanne Rapozo became the first female member in 1986, followed by Maggie Mah. (Courtesy Shack Riders.)

**JOHN VOLPIANO AND DALE RYMAN, LATE 1950s.** Fire Chief Volpiano (left) and Mounted Patrol horseman Ryman are shown here putting up a sign at the Woodside Training Stables. The building has been restored as a private stable. Horse trails run through wooded and grassy areas where there is fire danger. Today, the sign would probably also say, "No cell phones on trails." Ryman was president of the San Mateo County Horsemen's Association in 1971, captain of the Mounted Patrol and president of the Woodside Trail Club.

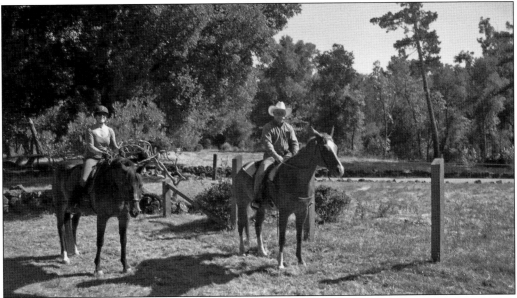

**TRAIL RIDE, 2011.** This photograph taken on Albion Avenue shows Woodside Trail Club secretary Maggie Mah Johnson (on the left), on Nancy; and Woodside Trail Club president Rick DeBenedetti, riding Sipper. The Woodside Trail Club was formed in 1922 by seven women, led by Elsa Schilling, to design a system of horse trails throughout Woodside. The club maintains the private trails. The town public trail system connects with the county network and adjoining open space trails.

**HUDDART PARK.** San Mateo County acquired this land in 1944 from the James M. Huddart estate. Located just off Kings Mountain Road, it is one of the most popular parks in the county, encompassing 973 acres of picnic grounds, hiking and riding trails, streams, wildflowers, redwoods, and other native vegetation.

**WUNDERLICH PARK.** In 1974, Martin Wunderlich donated 942 acres to San Mateo County to create Wunderlich Park. Located along Woodside Road, near Bear Gulch Creek, it offers public hiking and horse riding trails that wind up the hillside to vista points overlooking San Francisco Bay. The park is also home to the magnificently restored Folger Stable, now a national historic landmark.

# *Eight*

# PRIDE AND POLITICS

The small crossroads community of Woodside remained an idyllic country village long after the development of the surrounding areas in San Mateo County. As early as 1928, some residents proposed the concept of incorporating in order to determine their own destiny. In the years following World War II, the San Francisco Peninsula communities grew rapidly, and developers wanted to divide the large estates into smaller parcels.

In 1952, the Woodside Civic League was formed to study the pros and cons of incorporation and largely favored incorporation. Proponents felt the county had no particular interest in preserving the rural lifestyle and natural beauty of their community. Another group, the Woodside Property Owners Association, opposed incorporation; large land owners feared more government and taxes. The measure was put to a vote on October 21, 1956, and passed by only 21 votes. A council was formed along with a town government. The Town of Woodside was born.

A general plan was written with the help of planning commission secretary Abby Klein, setting forth the policies of the new town. Klein and longtime town clerk Irma Lewis were instrumental in forging the town government. In 1957, the new council officially, but unsuccessfully, protested the building of I-280, the Junipero Serra Freeway.

As the community grew, residents gathered for various events, some of which have become treasured traditions. The oldest of these is the May Day Parade, begun in 1922. The Village Church Rummage Sale is held each year in May and October. The Church Guild Hall serves as a monthly meeting place for the Rotary Club, which hosts pancake breakfasts, wine tastings, and other fundraisers. The church classrooms are used during the week by the Woodside Parent Cooperative Nursery School, begun in 1973 by Janet Koelsch, Sue Beugen, Karen Offen, Barbara Tagg, Lee Ann Gilbert, and others.

The Woodside Library holds a semiannual book sale and features a native plant garden maintained by the Woodside-Atherton Garden Club, which holds its popular biannual plant sale there. The Fire Station serves as a polling place and Santa Claus makes a stop there each December. The July 4th Junior Rodeo, Day of the Horse, the Environment Fest, Woodside Follies, Community Theatre, and other activities attest to the vibrancy of the Woodside community.

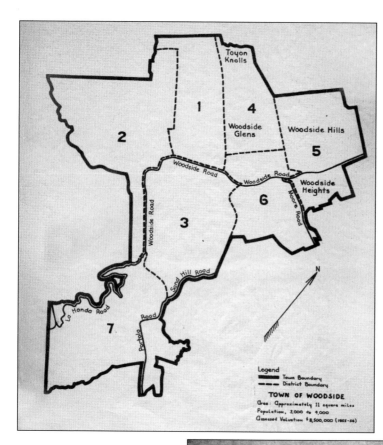

COUNCIL DISTRICTS MAP. At the time of incorporation, Woodside consisted of about 11 square miles divided into seven districts, with each district represented by one councilmember. The original boundaries were approved by the County Board of Supervisors, with Atherton and Redwood City to the east, Skyline Boulevard to the west, Sand Hill and Portola Roads to the south, and Jefferson Avenue to the north. Other areas to the east and north were incorporated in later years.

INCORPORATION, NOVEMBER 16, 1956. Members of the new town council gathered at the fire station to await the news from Sacramento that the secretary of state had certified the results of the incorporation election. Pictured here are, from left to right, councilmember Selah Chamberlain Jr., acting town clerk Jane Hicks (who served one month and was replaced by Irma Lewis), mayor William Lowe, and councilmember Rose O'Neill.

**JOAN OLSON, TOWN CLERK.** Joan Olson served as town clerk from the late 1970s to the 1980s and was known for interpreting town ordinances with a fair and even hand. This photograph shows her in one of her lighter moments, wearing roller skates to perhaps more quickly serve people at the counter. The current Woodside town clerk is Janet Koelsch.

**FIRST TOWN COUNCIL, 1956.** Following certification by the State of California, the newly elected Woodside Town Council wasted no time in establishing a town government. The town officials shown here are, from left to right, Selah Chamberlain Jr., Ben Eastman, Rose O'Neill, acting town clerk Jane Hicks, mayor William Lowe, Donald Graham, and Richard Marshall. Each member represented one of seven districts and was elected town-wide to a four-year term. Members of the council, planning commission, boards, and committees all serve as volunteers.

**YOUNG PROTESTORS, 1957.** The proposed construction of I-280 through Woodside became very controversial. Woodsiders had strongly opposed all three routes for many years. This was the newly formed Council's first galvanizing issue, with hearings beginning in 1957. The first proposed route showed the eight-lane freeway cutting through the center of town. Even the local schoolchildren, in costume at the annual May Day parade, joined the protest.

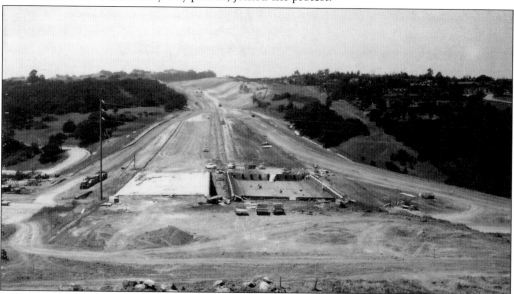

**I-280 UNDER CONSTRUCTION, 1974.** Construction of the freeway through Woodside continued for 18 months, with earthmoving equipment making massive cuts and fills in the verdant hillsides. Woodside was powerless to stop the State of California Transportation Authority from dividing the quiet rural town; however, local equestrians did succeed in securing two trail undercrossings.

**HAP HARPER AT OPENING OF I-280 IN 1975.** Local radio personality Hap Harper was the world's first flying weather reporter. He landed his airplane on the freeway at the opening ceremonies and helped cut the ribbon with other dignitaries. During the festivities, the band played the song "Do You Know the Way to San Jose?" (Courtesy Jan Harper.)

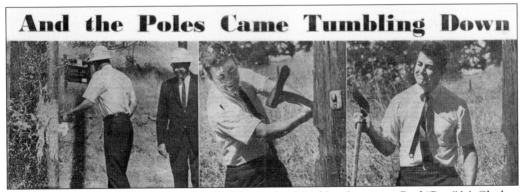

**PETE MCCLOSKEY.** Alec Donald and other Woodsiders hired local attorney Paul "Pete" McCloskey to represent the "Save our Skyline" campaign in the 1960s. The group succeeded in preventing the Atomic Energy Commission (AEC) from installing unsightly high-voltage towers in a clear-cut swath on Woodside's hillsides. The center image shows McCloskey symbolically cutting down a utility pole as part of the settlement with the AEC to install smaller towers. In exchange, Woodside agreed to underground utilities in town. Mayor Selah Chamberlain Jr. (with glasses) is shown in the left image. McCloskey later became a US Congressman.

**JACQUES AUDIFFRED, 1929.** The first May Day parade was held in 1922, proceeding east from the Woodside Elementary School to the intersection of Cañada and Woodside Roads and returning to the school for a maypole dance and community picnic. In 1929, Jacques led the charge as town crier, wearing a feather in his hat and ringing a bell to announce the start of festivities. (Courtesy Audiffred family.)

**PATTY HALLETT, 1949.** Nicknamed "Snookie," Patty Hallett Nance is a descendant of one of the early Woodside pioneer families. Here, Hallett is dressed as storybook character Little Bo Peep as part of the Mother Goose float in the May Day parade. She had help from Myra Josselyn Duncan in assembling her outfit. Hallett is a member of the Woodside History Committee. She lives in town and raises ponies with her husband, Jim Nance. (Courtesy Patty Hallett Nance.)

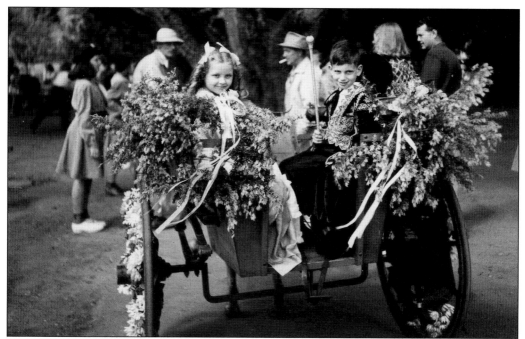

**MAY DAY KING AND QUEEN, 1947.** Every year, two kindergartners are crowned king and queen of the May Day festivities. Wearing paper crowns and fancy outfits, they ride in a horse-drawn carriage at the head of the parade. William Wilke (center background, smoking cigarette) decorated the cart with real flowers. Wilke's daughter Dolores was queen and David Lowe was king. Milo Petorovo-Miloradovich is in the background at left, wearing a hat. (Courtesy Dolores Wilke Degnan.)

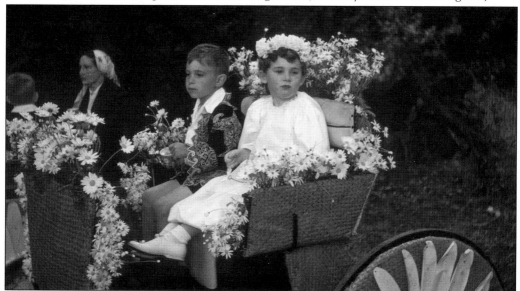

**KING AND QUEEN, MAY DAY, 1954.** Pictured here in a decorated horse-drawn cart donated by the Mein family, Steve Lubin was king and Shirley Alves was queen of the May Day festivities in 1954. Alas, the lovely queen had to abdicate shortly afterwards, as it turned out she was not old enough to be in kindergarten. Lubin went on to become a state champion cyclist and an architect. He lives in Woodside with his wife, Thalia. (Courtesy Steve Lubin.)

**COVERED WAGON, 1950.** William Wilke drives a wagon at the 1950 May Day parade, with Sally Norris next to him. Riding behind them are Linda Shine and Wilke's daughter Dolores. She is a member of the Woodside History Committee and is an equestrian who lives in town with her husband, Jim Degnan.

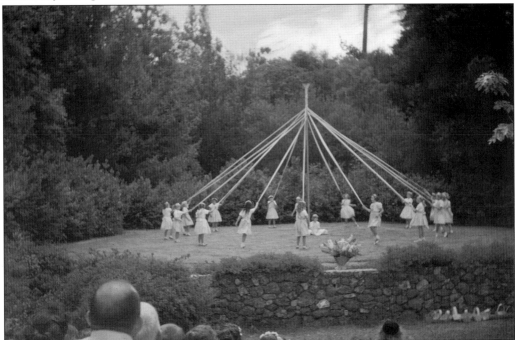

**MAYPOLE DANCE, 1956.** The coronation of the King and Queen and their attendants took place after the parade. The ceremony and the maypole dance were performed on the front lawn of the school grounds until this amphitheater was built in 1951. Here, third-grade girls dance and weave multicolored ribbons around the maypole. In later years, the dancers included boys and girls. (Courtesy Steve Lubin.)

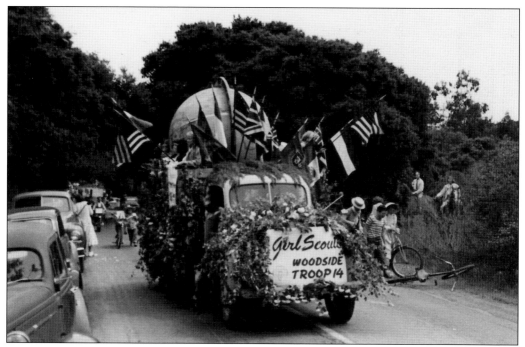

GIRL SCOUT TROOP 14, C. 1940. Beverley Williamson Toombs remembers that meetings were sometimes held at troop leader Helen Potter's house in the Woodside Glens. Troop 14 marched in the May Day parade carrying the American flag from the elementary school east to the old Shell station at Mountain Home and Woodside Roads and back.

BOY SCOUT TROOP, 1932. Among those pictured here are (first row) Henry "Hank" Gragg (third from right) and Harold Gragg (second from right). They were known in town as the "Double H" boys. Hank later became a butcher, working first at Holt's Grocery and then at Roberts Market. Harold became a grading and paving contractor.

**BASEBALL TEAM, 1895.** The fire department had a team that played other teams on a baseball diamond at vacant lot off Mountain Home Road, near the center of town. Pictured here are, from left to right, (first row) E. Early and H. McArthur; (second row) A. Booz, M. Booz, G. Greeley, T. Early, and J. Kelly; (third row) G. Fromhertz, G. Kreiss, C. Hayward, G. McArthur, and E. "Speed" Weeden.

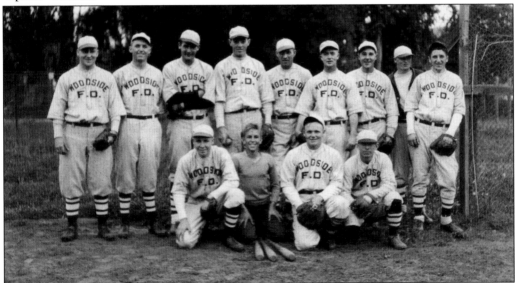

**FIRE DEPARTMENT BASEBALL TEAM, 1932.** Pictured here are, from left to right, (first row) gas station owner Carl Shine, batboy Fritz Silva, contractor Al "Peg" O'Neill, and Daniel Schimf; (second row) Thomas Shine, future fire chief John Volpiano, John Skrabo, Vern Kelly, Frank Magnen, Hugh O'Neill, Peter Duzanica, team manager "Tick" Hallett, and fireman George Jelich. Thomas and Carl Shine were the sons of blacksmith George Shine.

**McCovey Field.** The baseball field at the Woodside Elementary School was named in honor of San Francisco Giants baseball player and longtime Woodside resident Willie McCovey. The field was dedicated in 1981, and today the Woodside Recreation Committee hosts its league games there, with many local residents participating regardless of expertise. (Courtesy Jim Milton.)

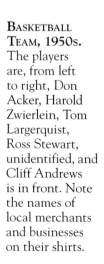

**Basketball Team, 1950s.** The players are, from left to right, Don Acker, Harold Zwierlein, Tom Largerquist, Ross Stewart, unidentified, and Cliff Andrews is in front. Note the names of local merchants and businesses on their shirts.

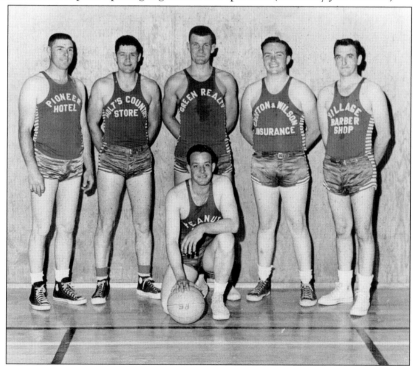

**WOODSIDE FOLLIES, 1950s.** Even local firefighters got into the act of community theater presentations. Performing a skit here are, from left to right, Walter Jelich, Smokey Stewart (with cigarette), Beryl Darnell (standing), Nick Jerian, William Wilke, and unidentified. The Follies were held annually at Scout Hall on Albion Avenue, with various community groups performing skits accompanied by a live band.

**FOLLIES, EARLY 1950s.** The Woodside Village Church group is shown here, with Thelma Wilke at far right, dressed as the Merry Widow. The women's dresses are from the 1800s and came from the attic of the McArthur house. The group members included, from left to right, (first row) Jim James, Hal Sanford, Roanne Lindquist, Bina John, Jo Lawrence, and Mr. Harvey; (second row) Mae Harvey, Emmylou Sanford, Helen Ambrose, Mrs. Sharpe, Lucille James, Mrs. Reynolds, and Thelma Wilke.

**Lions Club, 1950s.** As part of their community service, a group of "lions" would build a large bonfire in the parking lot in front of the Stagecoach Restaurant during the holidays to keep warm while they entertained customers with Christmas carols. Pictured here are, from left to right, Pat Grady, Beryl Darnell, Jacques Audiffred, and Keith Boyd. Today, the restaurant is called Buck's and is operated by Margaret and Jamis MacNiven and known for its quirky décor. It is also a popular meeting place for venture capitalists. (Courtesy Audiffred family.)

**Santa Claus at the Firehouse, 1995.** In this annual town tradition, fire chaplain Dick Morton assures visitors that the real Santa Claus visits the firehouse to distribute toys and candy canes to all children who have been good, like battalion chief Rawn Pritchard's son Chase, who is sitting on Santa's lap. Hot chocolate and cookies are served. This being horsey Woodside, few residents complain of reindeer droppings on their roofs as Santa's sleigh flies over the town. (Courtesy Dick Morton.)

SCHOOL OPERETTA, C. 1950. Seventh and eighth grades were combined for the operetta, with students writing their own scripts and performing together at the end of each school year. Among those pictured here, from left to right are (first row) George Stocksdale, unidentified, Teddy Lee, and Kenny Smith; (second row) Tommy Largerquist, unidentified, Betty Purvis, Raymund Rollins, and unidentified. English teacher and later school principal George Sellman organized the operettas beginning in 1958. The school auditorium was named in his honor.

EIGHTH-GRADE OPERETTA, 1990. The entire Woodside Elementary School eighth-grade class participates in the annual operetta. Beginning in 1958, the plays were performed in the new school auditorium. Parents assist with costumes and stage sets, the community is invited, and it has become a rite of passage for graduating seniors. Here, the class performs *Li'l Abner*. In the 1980s, George Sellman produced additional versions of the plays, featuring adults, as fundraisers for the PTA. (Courtesy Bibbler family.)

**MARDI GRAS, 1965.** This annual event, sponsored by the Woodside Village Church, was often held at the Guild Hall or the elementary school. For over 20 years, it was one of the premier social events of the community, with prizes awarded for the best costumes. (Courtesy Bob Mullen.)

**DAY OF THE HORSE.** Designated as an official town event in 2002, Day of the Horse is held annually in October. The Woodside Horse Owners Association (aka WHOA!) began hosting the event in 2004, co-chaired by equestrians Fentress Hall and Donna Poy. The local Wells Fargo bank offers stagecoach rides, blacksmiths show off their horseshoeing talents, and horses are given carrots on the trail rides. (Courtesy Fentress Hall.)

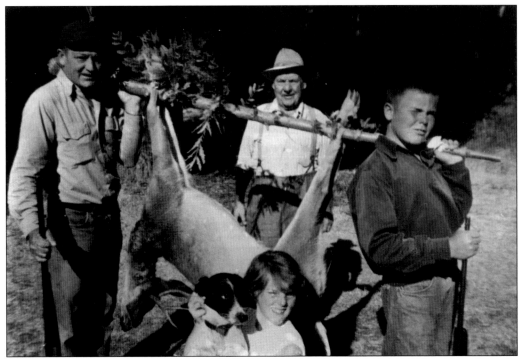

**HALLETT FAMILY OUTING, C. 1950.** Blacksmith George Shine (center) looks on while "Tick" Hallett helps his son Alvin "Bosko" haul his first deer out of the woods. In front is sister Patty "Snookie" with her dog Buttons. The Halletts were known for their unusual nicknames. (Courtesy Larene Hallett.)

**JACQUES AND EDNA AUDIFFRED.** Resident and firefighter Jacques and his wife, Edna, lived on Audiffred Lane with their three children, Dean, Beatrice, and Charmaine. In this image from the 1970s, they pose for a fire muster in Benicia. At fire musters, firefighter clubs gather to raise money for restoring fire engines, have hook-and-ladder competitions, reenact bucket brigades, and enjoy parades with their families. (Courtesy Audiffred family.)

**SHIRLEY TEMPLE.** Former child movie star and, later, US ambassador Shirley Temple married Charles Black and moved to Woodside, where she lives in a Tudor-style house. Shirley Temple Black was honored in the late 1970s as grand marshal of the May Day parade. Football quarterback Joe Montana, of the San Francisco 49ers, was grand marshal in 1982. Other notable Woodside residents include folk singer Joan Baez, Intuit founder Scott Cook, venture capitalist John Doerr, US Racing Hall of Fame jockey Russell Baze, and Intel cofounder Gordon Moore.

**PAUL FAY AND JOHN F. KENNEDY, 1963.** Paul "Red" Fay was a fourth-generation San Franciscan who summered in Woodside. Fay and Kennedy began their friendship after both survived the destruction of their patrol boats in the South Pacific during World War II. Fay was undersecretary of the Navy during the Kennedy and Johnson administrations. This photograph was taken to prove that Fay looked better in a hat than Kennedy. Fay and his wife, Anita, owned a summer home in Woodside that is still used by the family. (Courtesy Fay family.)

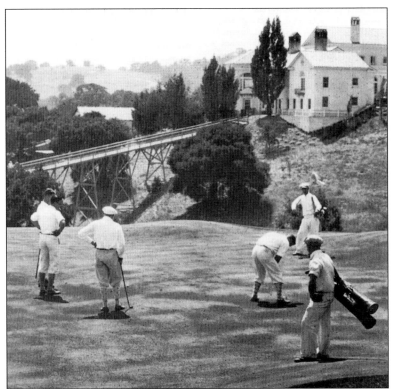

**MENLO COUNTRY CLUB, C. 1914.** This photograph shows the site with a bridge, before the ravine north of Woodside Road was filled. Formerly the Blinn Ranch, the country club was incorporated in 1909. The clubhouse was built in 1912 and remains a social gathering place, with an 18-hole golf course. Early officers included John Hooper, James Flood, James Folger, and Charles Josselyn, whose daughter Myra Duncan was one of the first female members admitted.

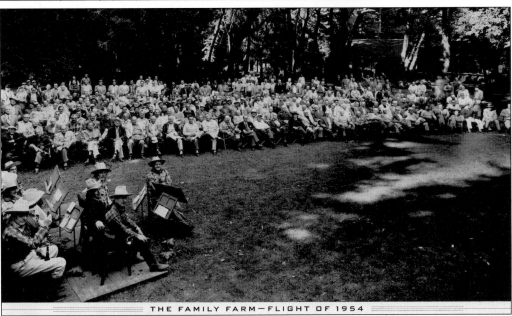

THE FAMILY FARM—FLIGHT OF 1954

**FAMILY FARM EVENT, 1954.** Former members of San Francisco's Bohemian Club and others formed a private male-only club called The Family. In 1909, this club established a rustic retreat with camp facilities near Searsville Lake. The clubhouse was built in 1914, and the surrounding land was preserved as open space. Annual events included a play, with members' families invited to attend.

**WALKING THE DOG ON TRIPP ROAD AND CYCLING ON MOUNTAIN HOME ROAD.** Despite a few dramatic changes, the Town has remained remarkably the same over the years, fulfilling a prophetic declaration by its first mayor, William Lowe, at the time of incorporation: "We have only one purpose and that is to keep Woodside the way it is." Indeed, through the vigilance of its residents and community involvement, Woodside continues to be a great place to live, raise a family, ride a horse, ride a bike, or walk a dog. (Courtesy Patsy Kahl.)

# BIBLIOGRAPHY

Gullard, Pamela, and Nancy Lund. *History of Palo Alto: The Early Years*. San Francisco, CA: Scottwall Associates, 1989.

Kahl, Patsy, and Marsha BonDurant. *Woodside: Making of a Town*. Woodside, CA: Town of Woodside, 2006.

Lund, Nancy, and Pamela Gullard. *Life on the San Andreas Fault: A History of Portola Valley*. San Francisco, CA: Scottwall Associates, 2003.

Postel, Mitchell P. *History of the Shack and the Shack Riders*. The Shack Riders, 1998.

Postel, Mitchell P. *Peninsula Portrait*. Northridge, CA: Windsor Publications, Inc., 1988.

Regnery, Dorothy F. *The History of Jasper Ridge*. Stanford Historical Society, 1991.

Richards, Gilbert. *Crossroads—People and Events of the Redwoods of San Mateo County*. Woodside, CA: Gilbert Richards Publications, 1973.

Schellens, Richard. San Mateo County newspaper cross-references, 1852–1971. Available at the San Mateo County History Museum archives.

Stanger, Frank M. *Sawmills in the Redwoods: Logging on the San Francisco Peninsula*. San Mateo, CA: San Mateo County Historical Association, 1967.

Stanger, Frank M. *Sawpits in the Spanish Red Woods: 1787–1849*. San Mateo, CA: San Mateo County Historical Association, 1966.

Stanger, Frank M. *South from San Francisco: San Mateo County, California . . . Its History and Heritage*. San Mateo, CA: San Mateo County Historical Association, 1963.

Svanevik, Michael, and Shirley Burgett. *San Mateo County Parks*. Menlo Park, CA: San Mateo County Parks and Recreation Foundation, 2001.

# INDEX

# Discover Thousands of Local History Books Featuring Millions of Vintage Images

Arcadia Publishing, the leading local history publisher in the United States, is committed to making history accessible and meaningful through publishing books that celebrate and preserve the heritage of America's people and places.

Find more books like this at
## www.arcadiapublishing.com

Search for your hometown history, your old stomping grounds, and even your favorite sports team.

Consistent with our mission to preserve history on a local level, this book was printed in South Carolina on American-made paper and manufactured entirely in the United States. Products carrying the accredited Forest Stewardship Council (FSC) label are printed on 100 percent FSC-certified paper.

MADE IN THE USA